MARION PIKE

THE ART AND THE ARTIST

MICHEL F. SARDA

BRIDGEWOOD
PRESS

Published by Bridgewood Press, an imprint of Sarda Resources, Inc., Phoenix, Arizona

Editor, Donnalee Ray Sarda

Marion Pike, 1913-

Marion Pike – the art and the artist

Includes chronology, bibliography, index.

Library of Congress 86-60950

Hard cover ISBN 0-927015-00-5

ACKNOWLEDGEMENTS

To Estée Lauder, Inc., Times Mirror, Inc., Vogue Magazine,

To the United States Presidential Archives,

To the National Museum of Singapore and the Frank Lloyd Wright Foundation,

To Ron Ballard and Subiacolor Professional Photo Lab, Phoenix

This book would not have been possible without the affectionate support of Marion Pike herself, who opened for me her heart and her work. Every minute of this cooperation has been an enlightening and memorable experience.

Her two children, Mrs. Jeffie Durham and Mr. John Pike, have been my companions from the beginning. Moreover, they gave me access to hundreds of letters from their mother, some containing very personal and sensitive matters, and this proof of confidence alone deserves recognition.

Marion's sister, Mrs. Jane Gillespie, has been an invaluable source of information and documents. Mme Josette Devin, besides writing a moving tribute for this book, was also a constant inspiration through her letters.

Marion Pike's friends and collectors have provided me with the most effective assistance throughout this project. I want to express here my gratitude to Mrs. Caroline Ahmanson, Mr. Jeffrey Angell, Mrs. Kenyon Boocock, Mrs. Sidney Brody, Ms. Claudette Colbert, Mrs. Eleanor Phillips Colt, Mrs. MaryLou Daves, Mr. and Mrs. André Desmarais, Mr. & Mrs. Joseph Gimma, Mr. Maurice Hodgen of Claremont Colleges, Mr. & Mrs. Bob Hope, Mme Magdeleine Hours, Mrs. Eleanor Howard, Mr. George LaBalme, Mrs. Christiane Lazard de Bord, Mrs. John McBride, Mr. and Mrs. David Parry, Mrs. Ariane Pike, MM. Pierre and Christian Raoul-Duval, Mrs. Lucille Simon, Mrs. Alex Spanos, Mr. Gerald Van der Kemp.

All my thanks to those who opened their houses for me, kindly sent me information and pictures, and expressed their support.

Among them, Mrs. Jackie Applebaum, Mr. and Mrs. John Brinsley, Mrs. William Bucklin III, Mr. Jake Butts, Mr. Sylvain Cabanau, Mr. and Mrs. Jean-Luc Chalumeau, Mrs. Justin Dart, Mrs. Anne Chamberlain, Mr. and Mrs. Gene Chenault, Mrs. William Coberly, Mme Suzanne Danco, Ms. Kit Fuller, Mrs. Narcissa Vanderlip Fuller, Princess Tassilo von Furstenberg, Mrs. Antoinette Haber, Mr. Prentis Hale III, Mr. Bruce Halle, Mrs. Enid Haupt, Mrs. Ruth Hofstetter, Mr. John Huneke, Mr. and Mrs. Frank Kelcz, Ms. Elizabeth Kujawski for Estée Lauder, Inc., Mr. Parker Ladd, Dr. Michèle Le Troquer, Mrs. Isabelle Lewis, Mrs. Caroline Liebig, Prince Edouard de Lobkovicz, Mr. Erick Mack, Mrs. Helen Mack, Mr. and Mrs. Brian Mulroney, Mrs. Tina McPherson, Mrs. Ronald Reagan, Mrs. Astrid Rottman, Dr. Irvin Sittler, Dr. Bradley Straatsma of the Jules Stein Institute, Mrs. Marilyn Stuart, Mr. Ernest Swigert, Mrs. Margot Thomas, Mrs. Janice Vest, Mr. and Mrs. Aubert de Villaine, Mme André de Vilmorin, Mr. John Walker III, Mr. and Mrs. Richard Walker, Mrs, Virginia Weaver, Mr. Lee Wesson, Mr. Greg Williams of the Frank Lloyd Wright Foundation, Prince Alexander of Yugoslavia.

Would that my wife Donnalee and my son Bruno receive my fond gratitude for the environment of confidence and affection they created and maintained for me throughout this work.

Michel F. Sarda

To Marion

*Art should lead to the affirmation of life and the
strengthening of man's faith in himself. Art must prove
its value by aiding in preserving and increasing the
force of life, heightening the purity of feeling and
willing, promoting the humanization of man.*
<div align="right">*Goethe*</div>

TABLE OF CONTENTS

MARION PIKE – the art and the artist

Beyond all great works of art
stands a tamed destiny.
André Malraux, *The Voices of Silence*

Artists of the twentieth century enjoy many privileges over the old masters, but one certainly dominates: the entire world is now their studio, their library, their backyard. The discovery of works from other cultures distant in space and time, – like African tribal art or Japanese calligraphy – deeply transformed the vision and the expression of contemporary artists. Gone is the time when Rembrandt had to sneak into auction sales, in his hometown of Amsterdam, to briefly study the works of Raphael and Titian. Today information about art is readily available in museums, books, video tapes, and illuminates in detail the history of humankind. An explorer of unchartered territories of art, Picasso admitted that "our knowledge influences our vision." Mobility and speed also characterize our epoch, and art, as the expression of a people, as the expression of a time, records those facts and translates them into its own language.

For her vast knowledge, the mercurial mobility of her life, her sense of urgency in capturing the present, Marion Pike is the quintessential modern artist. Although deeply rooted in the American and European traditions, she vanguards the worldwide culture that now emerges. For more than sixty years she welcomed all opportunities offered to her relentless curiosity and built upon them her eclectic and versatile personality. She traveled and studied like few artists ever have. Throughout the world she met people, of all confessions and origins. She met none with indifference, most with interest, many with compassion and insight.

An artist with high standards of integrity, Pike persistently ignored ever-changing trends and fashions. She painted her own representational way to mastery when abstraction was the rage. She agreed with Igor Stravinsky that "not everything has yet been said in C Major". She believed that "deep inside, art is of no time."[1]

To the astonishment of those who had the privilege to watch her paint, whatever the subject of her work, she persistently manifested a unique ability to capture the untold or the invisible, to translate the present into the timeless. She simultaneously absorbed and permeated the reality that surrounded her, not only at the immediate visual level but beyond, where feelings become forms, colors, magical architectures – all qualities that unmistakably distinguish a great artist.

Some of the most prominent art experts of this time recognized these qualities in Pike's art and celebrated her talent. André Malraux, the visionary essayist of *The Voices of Silence*, was her mentor and her friend for fifteen years. As were Norton Simon, founder of the museum bearing his name in Pasadena, Richard Brown, Director of the Los Angeles County Museum, John Walker, Director Emeritus of the National Gallery in Washington, D.C., Sir Kenneth Clark, Director of the National Gallery in London, or Magdeleine Hours, Director of the Louvre. They all sat for her. Acknowledging her expertise in the old masters, which spans from Piero della Francesca to Van Gogh, some even asked for her advice when considering a major acquisition. All this tells more than words can achieve.

In a time of many tormented artistic personalities, Marion Pike believes in simple values, like honesty and work. At peace with herself, she radiates a healthy and somewhat defiant happiness that survived the many ordeals of her life. Her special relationship with children, translated into many exquisite portraits, reveals an unspoiled mind. Contemplating a recent self-portrait, powerful though not especially flattering, she smiled and stated, "I worked all my life for this face."

Bonjour, Marion Pike.

*

Born on a California ranch, Marion Hewlett Pike belongs to the aristocracy of the American West that pioneers founded upon their bravery, values and faith. Her direct ancestry includes Benjamin Rush, signer of the Declaration of Independence and first Surgeon General of the United States, and the legendary Kit Carson. In her hometown of San Francisco, at the crossroads of Asian and Western cultures, she received at a young age an international awareness and education. She traveled to Europe with her family, then to Japan and China when she was still a teenager.

Her good temper and indefatigable energy earned her a stream of nicknames: "Dynamite Hewlett", "Cannonball Hewlett", "Speedball Hewlett". The four years Pike spent at Stanford University, where she was admitted at age fifteen, revealed her unusual athletic abilities. From 1930 to 1933, she set several university sport records before graduating in Asian History.

It is worth noting that Pike's creative activity is never exclusively intellectual. It usually implies a physical involvement, with an attraction to challenges – as in the huge portraits that became her trademark. Some of them are so large that a ladder is required to reach them with a brush. A natural *participant*, Pike cannot watch passively from the sidelines, she does not witness, she creates the event. She needs to surround herself with her subject – to feel it. While in Barbados, she sets her easel in the water to capture the ocean and the sky.

What initially triggered her desire to paint? As always, explanations are frivolous. Was it the natural beauty of Carmel where she spent the summer after her graduation? Or the opportunity to take art classes to add to her already impressive list of achievements? Her first sketch was a portrait of her sister Jane, for which she received encouragements from the respected artist William Ritchel. It helped her neophytic enthusiasm rapidly evolve into a profound commitment to art.

Marion Pike had found her way. Her first pictures belonged to the American realist tradition, then represented by George Bellows and Edward Hopper. Reality was all she wanted to paint, not the superficial appearance of people or objects, but, rather, their deeper identity or significance.

When she contacted Frank Lloyd Wright in 1947 for the design of a new house, Marion Pike had been a wife and a mother for more than twelve years. The master architect recognized in her an innate artist. His innovative design included a large exhibiting space – a luminous gallery con-

necting living areas. That was clearly the "house of a painter".

Unfortunately, the house was never built. An unexpected divorce, a sudden and painful change in Pike's life created the conditions that metamorphosed the social chrysalis into a dedicated artist. Painting became for her like oxygen and breath itself – literally, a way of life. She explored techniques and styles with such an appetite that the essence of her artistic personality was established within a few years.

For instance, in the early fifties, she experimented with "drip painting" on canvases laid on the floor. Unlike Jackson Pollock, who used this technique extensively, her result was not abstraction – but always a human face. In her most instinctive outcome, she still expressed an outward, sensitive and readable message. In 1955, she acknowledged her new self with a one-woman show in San Francisco, a success that was not the great beginning all her friends acclaimed – but, rather, for her, the end of the beginning.

Her move to Paris opened a new chapter in Marion Pike's life, as it did for Mary Cassatt a century before. And in an interesting wink of time, while working every day at the Louvre, studying and copying the most intimidating masters, Pike met Julie Rouart, the daughter of Berthe Morisot and Eugene Manet, themselves close friends of Cassatt. Julie, the lovely little girl once represented in many impressionist scenes was now a frail old lady who lived surrounded by masterpieces signed by Manet, Renoir, Degas, Monet, in a house where time had stopped and life continued as in the 19th century. She accepted to sit for one of Pike's

first portraits in the French capital.

Marion Pike's new Parisian residence gave her life a swirling mobility pattern. Most European countries received her frequent visits, though she showed a marked preference for Italy. In Venice, she captured the special quality of light, the gracious skyline, the airy contrast between the fluidity of water and the delicate ornamentation of buildings – she transformed the city into a life-irrigated subject with a regard of its own. In Florence, she rendered the soothing garden-like quality added over time in the Tuscany countryside by an industrious human presence. Both cities became recurrent themes for her tiny landscapes – windows peeping over the very soul of these history-rich and enchanted places.

Every year took her back to New York and her native California. Bicultural and ubiquitous, Pike painted Norton Simon, Lucille Simon and Howard Ahmanson in Los Angeles, John Walker in Washington, D.C., while Mary McCarthy, Louise de Vilmorin and sculptor Alberto Giacometti were her models in Paris.

In 1967, Marion Pike met the octogenarian "Coco" Chanel. For four years they shared a friendly relationship until Chanel's death. A formidable Parisian figure, with her hypnotic gypsy eyes, her stormy and generous personality, Chanel contributed to activate even further Pike's creative whirl. Her paintings and her subjects then acquired monumental dimensions in both vision and size. Revealingly, the two largest portraits Pike ever painted are of Chanel and herself. Florals (including the "Large Gloxinia" Malraux admired),

abandoning their pots and vases for a passionate struggle between color and form, were given a gigantic scale of their own. At the same time, Pike developed "a passion for landscapes", and began to paint the endless cornfields of Sologne and the skies of Barbados.

Her small hideout in Sologne ("a far cry from a chateau – but I wouldn't trade. This is one of few places where I feel absolutely happy."[2]) initiated a love affair with the French countryside, and to properly render its diversity, she developed a variety of styles. Says Pike,"I paint the way I feel – and I don't feel the same everywhere."[3]

During her yearly visits to her friend Claudette Colbert in Barbados, she still listens, her feet in the sand, to the conversational exchange between the sea and the sky, in changing lights and colors. From dawn to sunset, with the amazing speed and accuracy of a calligrapher, she captures on paper volatile architectures of clouds and the subtle gradations in shades and tones they imprint on the surface of the ocean.

Her adopted hometown, Paris remained for Marion Pike a source of inspiration. Enjoying a studio with a view – overlooking the Seine and the Pont-Neuf on one side, the tumultuous geometry of Paris rooftops on the other, she painted infinite variations of these themes, in every season, and at night, expressing with poetic virtuosity the mysterious glow that emanates from the City of Light, or the spectral silhouette of Notre-Dame in the haze.

She experienced what Robert Henri praised as "this incessant need for self-renewal, for going forward and further, without being ever self-satisfied with accumulated practice or success." [4] In constant self-questioning, she was obsessed with perfection. Her creative mood swinging from exaltation to despair, she confessed, "If you look at Rembrandt and see the design of the lights and darks, the structure, the luminosity – the solidity – you can only be honest and say you know nothing."[5]

Like Georgia O'Keefe before her, Pike was reluctant to exhibit her work in art galleries. She always preferred the more reverent environment of museums. She refused all her life to consider art as a commodity, a subject of blind speculation. "Wrapped up in life, in human feelings" [6], she was confused and unwilling to position herself within the multitude of groups representing – or claiming they represent – contemporary art. Beyond her constant doubt, rejecting what she called the "cheapening of art", she knew she belonged to an authentic stream of its evolution, away from the new academism of abstraction.

*

Her self-portraits are among Marion Pike's most distinctive works. As it was for Picasso, Edward Hopper, more recently Francis Bacon, or for Van Gogh and Rembrandt before them, the depiction of her own face was an open field for experimentation and self-analysis. More than fifty self-portraits, spanning half a century, unfold the story of her relationship with herself

and her art, from shyness to determination, from passion to serenity, from awkwardness to mastery.

Nowhere does Pike's personal world come to light more irresistibly than in the monumental self-portrait she completed in 1970 – possibly the largest ever painted (cover and p.75). Indeed, there is an hypnotic appeal in this portrait. Is it the size? It inspires awe – you need to step back, moved by a subtle force. Is it the mystery of the *leonardesque* expression, its straightforward look and unfathomable combination of feelings?

Norton Simon wanted this painting, but Pike wouldn't sell. As if they were conveying ineffable secrets, Marion Pike's self-portraits never smile – they radiate.

Portraits are what initially attracted her to painting; this interest never faded. A "painter of people", as Frederick Wight characterized her, Pike opened new grounds in portraiture with her "Big Heads" (the name given by Norton Simon). Her first subject was sculptress Cornelia Runyon in 1954. This enlarged representation of a face, still modestly sized compared to many to come, was the logical conclusion of Pike's quest for her model's personality. In removing the body from the portrait, in eliminating all superfluous details in clothing or background, in working on oversized boards which allowed her to use large brushes and to create a variety of textures, Pike's portraits offer a looking glass to peer into the subject's intimate identity.

She dealt with the specific dilemma of portraiture – a deterring difficulty for many contemporary artists: where to draw the line – literally – between artistic freedom and the likeness legitimately expected by the model? Beyond technique, she strived essentially "to bring the perceived and the real together" on canvas, recognizing that it is "always an enormous conflict when I do commissions."[7]

In *The Voices of Silence*, André Malraux remembers "hearing one of the great painters of our time warn Modigliani, 'You can paint a still life just as the fancy takes you, your customer will be delighted; a landscape, and he'll be even more delighted; a nude – he may be a bit worried; his wife – it all depends on how she'll take it. But when you paint *his* portrait, if you dare to alter his sacred face – well, you'll make him mad!'"[8] Following Rembrandt's example, Pike believed that "portraiture [means] neither idealization nor the rendering of expression. It strikes deeper – to the soul."[9] Magdeleine Hours, then head of the Laboratory at the Louvre, discovering her finished portrait, exclaimed, "It has a presence – *beyond art*!"

Because Marion Pike always shared, with convivial simplicity, the exhilaration of her creativity, many became her friends when sitting for her. Her work on the canvas progresses with rapidity from dark to light, in a birth-like process the model watches with amazement. Pike's art of portraiture is that of a *listener*. Attentive to her own perception, she also listens intensely to her subject, establishing what some called a "psychic" connection. She reached and expressed with acute intuition the identity of individuals who came from vastly different social or cultural environments. André Malraux also pointed out the spiritual dimension of many among Pike's portraits. With dazzling perspicacity, ob-

serving how they "go beyond mere imitation in their likenesses", he recognized in them the "pensive gravity of the Fayum art...which has learned the secret of a gaze that is not the expression of a fleeting moment."[10]

This mysterious relationship with her portraits calls to mind one of Marion Pike's stories, about Piero della Francesca, blind in his old age, who was taken to see his frescoes at Arezzo. After he ran his hand on the wall over the Queen of Sheba, Piero said, "Next time I would make her straighter!"

With identical insight, florals originated themes and styles of their own throughout Pike's work. From the opulent Roses of the beginning to the giant Poppies of the '70s, from the wrestling Gloxinias to the graceful elegance of recent Irises and Lilies, she explored the floral world like a wandering bee, progressing from static representations of *bouquets* in vases to dynamic fresco-like landscape florals. As in a portrait, she acknowledges the uniqueness of each flower and, in infinite variations of shapes and colors, she expresses it like a visual perfume.

*

Marion Pike's work creates a world where innocence is not *naïveté* but sharper perception of intrinsic realities. She knows that "things have their way to return our look upon them. They seem indifferent because our look is indifferent. But for a clear eye, everything becomes a mirror; to a sincere gaze, everything gets depth."[11]

For Marion Pike, art is not – has never been – the "more or less convincing lies" suggested by Picasso. For this twentieth century painter, art is the expression of an overwhelming truth that has to be endlessly chanted, with the fervor of a prayer, until the spirit is right, until something wonderful happens.

NOTES

[1] Marion Pike, letter to son John, May 1972
[2] Marion Pike, letter to son John, June 1967
[3] Marion Pike, to the author, 1989
[4] Robert Henri, *The Art Spirit*
[5] Marion Pike, letter to daughter Jeffie, December 1965
[6] Robert Henri, *The Art Spirit*, p. 111
[7] Marion Pike, letter to daughter Jeffie, January 1974
[8] André Malraux, *The Voices of Silence*, p. 117
[9] Ibid., p. 471
[10] Ibid., p. 194
[11] Gaston Bachelard, in René Huygue, *L'Art et l'Ame*, p. 21

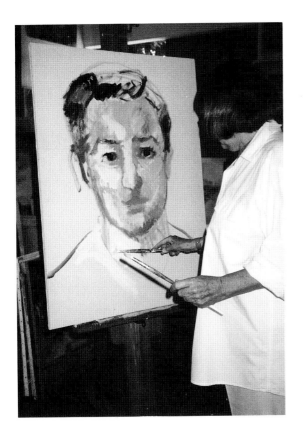

Marion Pike working on the portrait of the author,
Los Angeles, 1989

Ten years ago, when I met Marion Pike in Paris we first discussed the merits of various interpretations of Verdi's Requiem. Our friendship was established. When introduced to her work, I experienced what can only be described as the exhilaration of suddenly entering a non-polluted world.

As an architect I was familiar with art, with its history and its contemporary convulsions. Like many, despite a unquestionable belief in the virtues of artistic freedom, I was disturbed as much by some extreme egotistical manifestations in modern art as by the dubious speculation – both intellectual and financial – that promoted them. Along with architecture, I was taught irreverence at the Beaux-Arts, and I would not call art whatever hung on a wall. Marion's work appeared to me like windows wide open onto depths of light – an art to enjoy and meditate.

This book serves a simple and ambitious purpose: to introduce the reader to the work of a great artist. A simple project, because the timeless beauty of Marion Pike's paintings speaks for itself – but ambitious, for her protean production had first to be identified and catalogued, and resisted the narrow boundaries of a book.

André Malraux, Marion's long-time friend, wrote: "every painter of talent feels that trying to write about his art is completely futile." Marion Pike not only agreed, she extended this restriction to her life: this book would *not* be a biography. This wish was respected, not without some frustration for leaving out a wealth of wonderful stories.

The collected materials are presented in a unobstrusive manner. The illustrated Chronology reveals the extent of Marion's involvement in her time. A selection of color plates introduces to the diversity of her art. The Selected Themes offer some insight into several of her favorite subjects. Several appendices provide additional related information.

My wish is for the reader to share the pleasure I experienced in preparing this book.

Michel F. Sarda

THE LIFE OF AN ARTIST
An illustrated chronology

The work of an artist is nothing but this errance to eventually find, by the detour of art, these two or three great and simple pictures on which the heart broke open for the first time.

Albert Camus

What makes the artist is that in his youth he was more deeply moved by his visual experience of works of art than by that of the things they represent.

André Malraux – *The Voices of Silence*

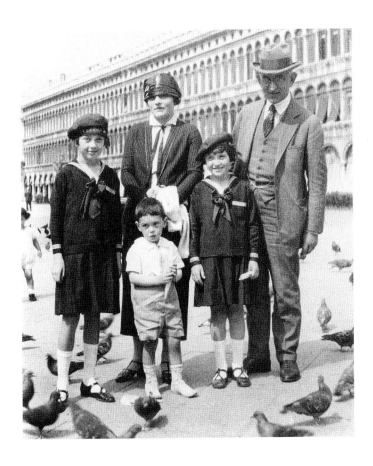

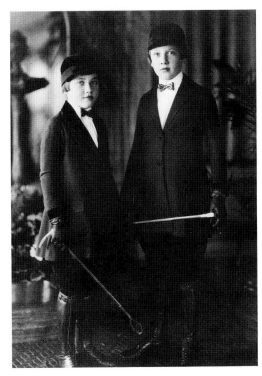

Clockwise from top right:

1 - Marion with classmates (top row, center) at Grant Grammar School, San Francisco.

2 - Jane and Marion Hewlett, 1925

3 - The Pauson family in Venice, 1924. From the left: Marion, Frank Pauson, Rose, Jane, Samuel Pauson.

1913 August 14, birth of Marion Hewlett to George and Rose Hardin Hewlett, at the family ranch in Mendocino County (California).

1916 Birth of Jane Hewlett, Marion's sister.

1921 Marion's mother, divorced from George Hewlett, marries Samuel Pauson.

1924 First trip to Europe. In Paris, 12-year old Marion discovers the Louvre, where a Delacroix retrospective makes an "unforgettable impression" on her.

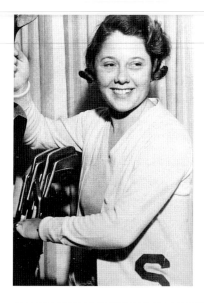

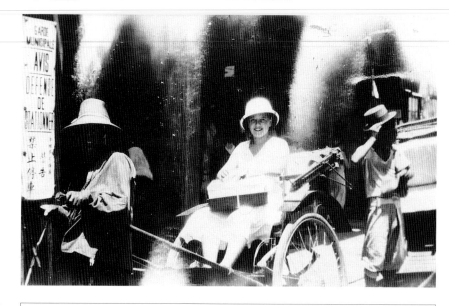

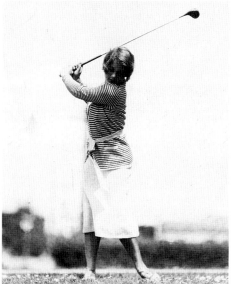

Reprint from

The Stanford Daily, Monday, May 8, 1933
(front page)

HEWLETT GOES HOME
PI PHI'S & AKL'S MOURN

"Who'll take my place?"
Asks Speedball As Diploma Looms.

Loss of Stanford's biggest feminine asset was the theme of the Marion Hewlett wake held in the Pi Phi house last night, when Queen Emeritus Hewlett told the assembled multitude that but forty-two days remained before her graduation this spring and so far there was no one to approach her...

Four years ago Miss Hewlett arrived on the campus and immediately made a wide place for herself. Woman of destiny from the first, she became a bray among subdued whispers...

Strong supporter of everything Stanford, Miss Hewlett is best remembered for her gallant support of her consort, King Prelsnik, the liberal monarch of last year's Masque Ball. Although the king does not remember the events of that night, Miss Hewlett's purchases of liniment the following day are well remembered by Palo Alto merchants.

Members of the Alpha Tau Omega fraternity, when questioned concerning the departure, approved of the idea when they stated that the resultant quiet would mean an average of two more hours of sleep per night for each brother.

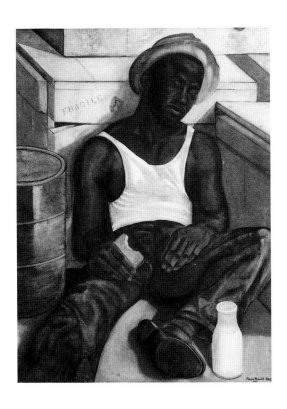

Clockwise from far left:

4 - On the golf course, 1932

5 - Member of the "S" team.

6 - Marion in Shanghai, 1932

7 - "Black Worker Asleep"
 1935, oil on canvas, 90 x 70 cm

1929 At age 15, Marion enters Stanford
 University.

1930 Second trip to Europe: Paris, Switzer-
 land, Italy, Austria, Hungary.

1932 Trip to Japan, China and Korea.
 Summer school at the Imperial Univer-
 sity in Tokyo. Celebrates 19th birthday
 in Beijing.
 Awarded the Stanford "S" blanket for
 outstanding achievements in sports. In
 golf, sets course record for women.

1933 June – graduates from Stanford with
 honors in Oriental History.
 Spends the summer in Carmel, where
 she takes painting classes.
 First portrait of her sister Jane.
 Gets encouragement from painter
 William Ritchel.

1934 Attends art classes in San Francisco
 with Marion Hartwell and Rudolf
 Shafer. Spends another summer in
 Carmel – first portraits in oil. Exhibits
 at the Carmel Art Gallery.

1935 May – marries John Jacob Pike in
 Saratoga. Honeymoon in Mexico.
 Exhibition at the Oakland Museum of
 Art – receives an award for the "Black
 Worker Asleep".
 The couple moves to Ventura, where
 the Pike family business, Republic
 Supply Company, has a branch office.

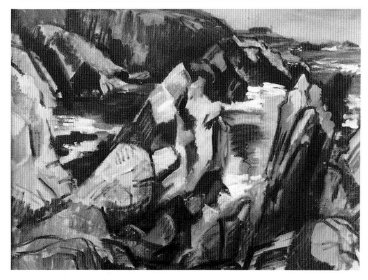

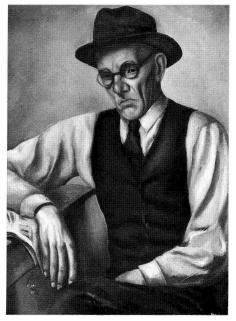

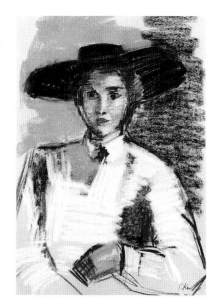

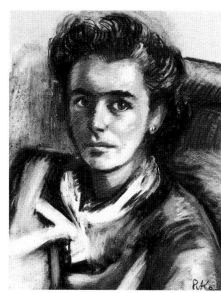

Clockwise from center left:

8 Sketch on paper, 1939

9 Rocks at Pebble Beach
 Circa 1938, oil on canvas

10 Andrew Hoisko
 1939, oil on canvas

11 Self-portrait (facing page)
 1942, pastel on paper

12 Beach scene (facing page)
 1939, oil on cardboard

13 Doogie Boocock
 1942, pastel on paper

14 Dolores Hope
 1942, pastel on paper

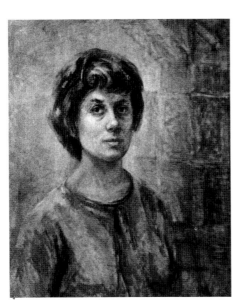

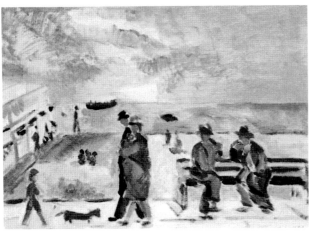

1936 Marion and Jack Pike move to Los Angeles.
Trip to Panama.

1938 New house on June Street – builds a studio,
where she works with watercolorist Tom
Craig.
Accompanies husband on numerousbusi-
ness trips throughout the United States.

1939 Trip to Hawaii.

1940 Birth of daughter Jeffie (as the family
story has it, Marion, already in labor, stops
at Ted Gibson's art store on her way to the
Good Samaritan hospital to discuss the
framing of a picture).
First trip to Guatemala, during the winter.

1941 December 3 to 14, exhibition at the
Hatfield Gallery in Los Angeles.
December 7, Pearl Harbor.

1942 Jack Pike's defense contracts necessitate
a sudden move to Northern California.
The couple stays at Alma Spreckels' house
in San Francisco. Marion meets opera star
Licia Albanese.
Birth of son John, in San Francisco.

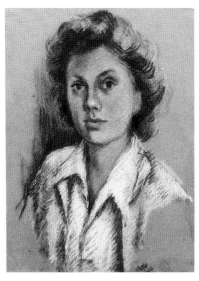

Clockwise from left:

15 - Self-portrait, pastel, 1946

16 - House on Muirfield Road

17 - Perspective rendering of the Pike House,
 designed by Frank Lloyd Wright, 1948

18 - Frank Lloyd Wright, drawing, 1948

19 - Iovanna Wright, pastel, 1948

20 - Adolf Bölm (Pavlova's partner),
 Charcoal and pencil, 1946

21 - Dolores Hope, pastel, 1947
 (Frank Lloyd Wright approved of this sketchy
 portrait, saying, "Don't polish the apple !")

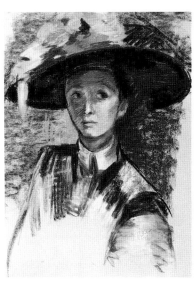

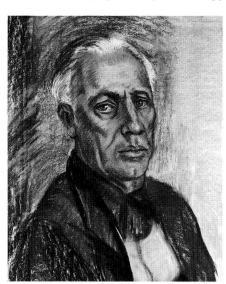

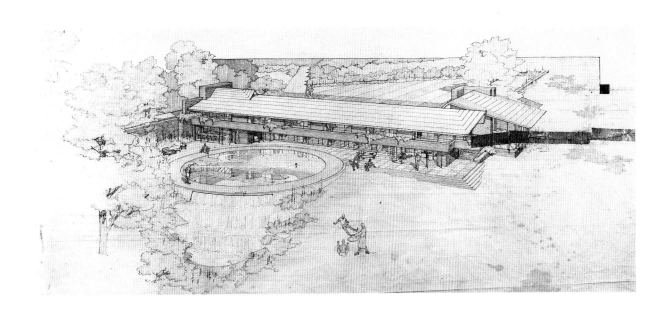

CHRONOLOGY

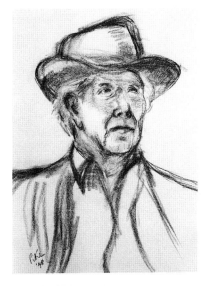

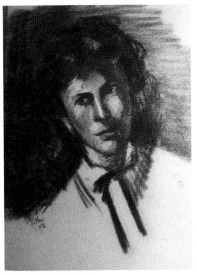

1943 Purchase of the house on Muirfield Road in Los Angeles – where the artist still has a studio.

1946 Numerous portraits in pastel.

1948 Meets with Frank Lloyd Wright to discuss the design of a new house on the Los Angeles Country Club. Several trips to Taliesin East and West.

1949 Trip to Europe.

1950 Divorce.

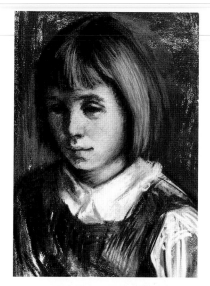

After her divorce, Mother went to work, not nine to five, but noon til dawn. She was always asleep when I got up to go to school, but on the stairway was a new picture! By afternoon when I got home, the house was alive with music (opera played at disco decibel levels) – and friends. While Mother painted in the library (transformed into a studio), a steady stream of people dropped by to say hello, give a critique, pose, pour out troubles, discuss a love affair, laugh, cry, practice the piano, cook, install a stereo, paint the kitchen, fix a drain.

Nicknamed "Auntie Cuckoo", Mother seemed to thrive on this slightly madcap amount of activity, and in the middle of it all to do her best work. But she did not just paint the people who came to sit for her – she listened to them. With children, she usually embarked on the adventures of a bear named J. Archibald Twiddlebottom and then asked the child to help tell the story, so that it became his own, not hers. With adults who entered her studio and her life, she was also a great listener, one who made immediate, deep and lifelong connections. Many became regular house-guests. Licia Albanese used to stay with us and I remember her spending the day vocalizing and cooking (live eels in the sink!) before going downtown to the Shrine Auditorium to become Madame Butterfly. Then after the performance, she would rush back to take charge of the midnight supper at our house. Richard 'Ric' Brown – a friend, mentor, and then director of the Los Angeles County Museum – said it was the only 'salon' in Los Angeles. Dolores Hope said, "Here we take off our masks." But it was the caption on a small rug, given to Mother by Sue Vidor as an entrance mat to the studio, which perhaps said it best, "What *would* we do without friends?"

Jeffie Pike Durham

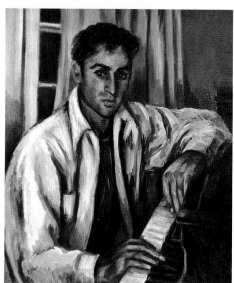

Clockwise from opposite top:

22 - Self-portrait
 Acrylic on board, 1952

23 - John (bottom right)
 Pastel, 1950

24 - Terrace at Deer Springs Ranch
 Drawing, 1951

25 - Deer Springs Ranch
 Drawing, 1952

26 - Dan Gordon at the piano
 Acrylic on board, 1952

27 - Jeffie
 Pastel, 1951

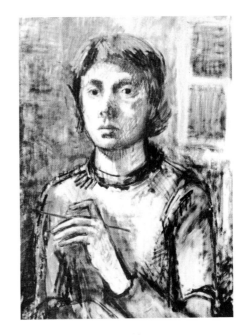

CHRONOLOGY

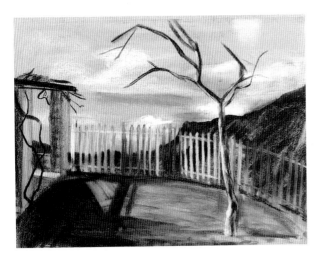

1950 Beginning of a new life.
 The house on Muirfield Road
 becomes the center of intense
 creative activity.
 Pike now dedicates all her time to
 painting.

1951 Frequent visits to Deer Springs
 Ranch in the Santa Monica
 mountains.

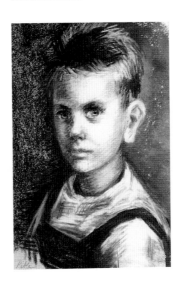

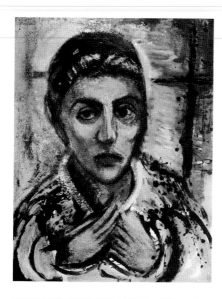

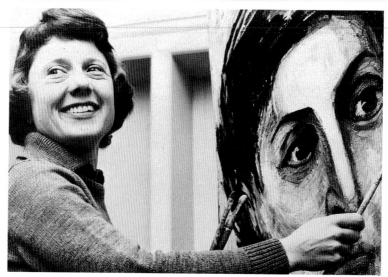

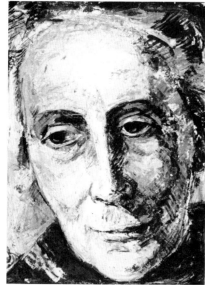

From top, left to right :

28 - Licia Albanese singing the Verdi Requiem
 Acrylic on board, 1953

29 - Marion Pike working on a Large Head of Licia Albanese, 1954.

30 - Cornelia Runyon, Pike's first Large Head.
 Acrylic on masonite, 1954

31 - Olive Berhendt
 Acrylic on masonite, 1954

32 - Marion Pike painting Licia Albanese at the Warner Studios, 1955

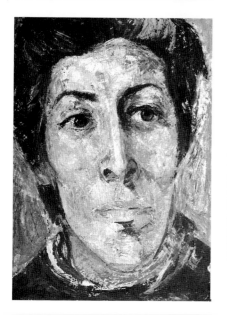

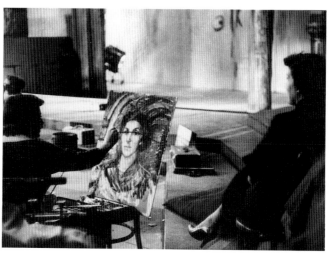

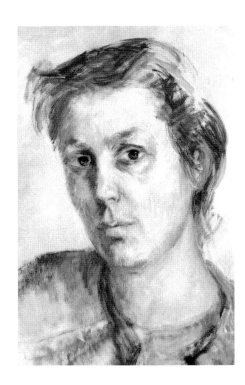

"In Dorothy's studio, I learned many new and free techniques that enabled me to break through. She was an incredible catalyst for me and many others."

<div style="text-align: right">Marion Pike</div>

CHRONOLOGY

1953 Takes art classes with Dorothy Royer in Los Angeles. Paints her first "Big Head" (the name given by Norton Simon), a large portrait of the sculptress Cornelia Runyon, painted on the floor in Dorothy Royer's studio, after "drip painting" experiments.

1954 Starts developing a neo-expressionism of her own ("eggheads" – see *The Silent Ones*, p. 26).
 Involved in the creation of the new Los Angeles County Museum.

33 - Dorothy Royer (top)
 Acrylic on board, 1954

34 - Anonymous caricature of Marion Pike, circa 1955

Artist's Talent Lies in Personal Qualities

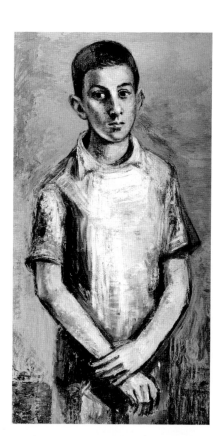

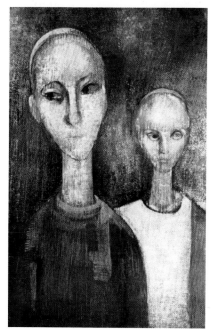

There is constant activity in a certain large home on Muirfield Road, for here lives one of California's foremost woman artists, Marion Hewlett Pike. Here she paints, mothers her two children with pride in their camaraderie, entertains a fabulous circle of friends from throughout the world, and meanwhile produces pictures of great talent in the midst of a gay but orderly pattern of days.

Critical acclaim and numerous awards speak for the excellence of Marion Pike's work, but the real key to the artist lies in the woman herself. Vitally alive, with a warm and compassionate interest in humanity, her basic characteristic is an intellectual and spiritual honesty that endeavors to strip life of its non-essential components. This refreshing simplicity is immediately apparent in both the woman and her work, for it is a simplicity achieved above and beyond sophistication.

The growing reputation of this California artist is attested by the more than 750 people who jammed the opening of her first one-woman show at the California Palace of the Legion of Honor in San Francisco in October.

A portraitist of penetrating insight, Marion Pike paints with love and understanding of the individual. Occasionally she ventures into the abstract, producing symbolic generalizations that are more than personalities. Rather they are renditions of archetypes of temperament and mood with something of the brooding quality found in Byzantine work. Painting with amazing speed, she sometimes completes a canvas in five hours and in a frenzy of creative energy once finished eight pictures in ten days.

A petite woman with warm brown eyes, a pert nose and fine strong hands often used in graceful gestures, she is a stimulating conversationalist. Music courses through the house in a constant stream of inspiration. Many of the artist's friends are artists of such outstanding caliber as Licia Albanese, an always-welcome house guest; Leonard Pennario, famed young pianist; Edgar Lustgarten, the well-known cellist, and numerous others. Here they find laughter, good counsel and a concordant meeting of the minds embracing all the arts.

[Marion Pike's] fine sense of values is without pretense, for she has seen and assimilated the best. To the woman and the artist, humanity in all its strength and weakness is the most important thing in the world. The sincerity of this conviction, coupled with talent, discipline and the will to work, has given us Marion Hewlett Pike, painter of people, and a distinguished citizen in the wide democracy of the arts.

Lenore Hunter
Reprinted from the Los Angeles Times, December 18, 1955

"You really gave this town a thrill."

Hector Escobosa
President of I. Magnin, San Francisco
(letter to Marion Pike, November, 1955)

1955 June – exhibits at the Los Angeles County
 Museum Annual Exhibition. Wins an
 award for the portrait of Tony Hope.

 Summer – exhibits at the Laguna Festival
 of Art (Award).

 October – One-woman show at the
 California Palace of the Legion of Honor in
 San Francisco.

 December – Los Angeles Times "Woman
 of the Year".

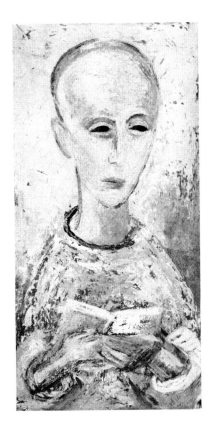

35 - Portrait of Tony Hope (facing page, top)
 Oil on masonite, 1954

36 - The Silent Ones (facing page, bottom)
 Acrylic on board, 1954

37 - Marion Pike, 1955 (above)

38 - The Yellow Man (left)
 Acrylic on masonite, 1954

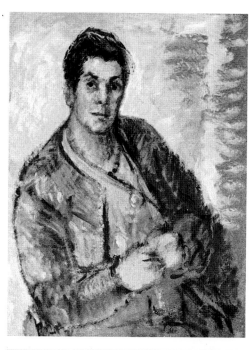

39 - Self-portrait (above)
 Oil on canvas, 1957

40 - Custodian of the Louvre (left)
 Acrylic on board, 1958

41 - Saint-Germain-des-Prés (below left)
 Oil on canvas, 1958

42 - Pont-Neuf (below)
 Acrylic on cardboard, 1957

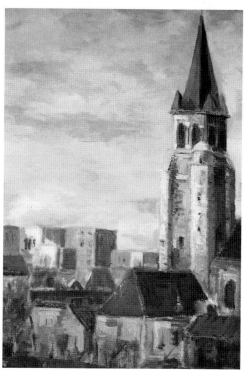

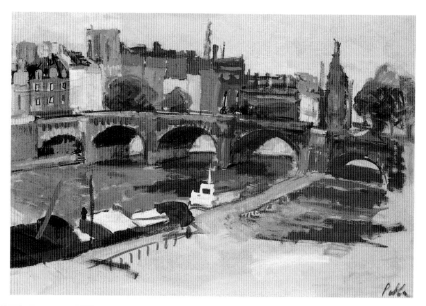

1956 May – exhibits at the Los Angeles County Museum.
Summer – in San Francisco and Los Angeles, starts a group portrait of the Lazard children.
Trip to Europe: Amsterdam, Italy, Greece, Turkey.

1957 In March, goes to Paris to complete the Lazard commission. Rents Malvina Hoffman's studio. Decides to live more permanently in Paris.
May – exhibits at the Los Angeles County Museum.
December – Group exhibition at the Los Angeles Art Association.

1958 May – exhibits at the Los Angeles County Museum. Moves to Paris, and settles at the Madison Hotel on the Boulevard Saint-Germain. Goes to the Louvre every day to copy the old masters. Paints neighbors and Parisian landscapes. Summer in Ibiza, Spain.

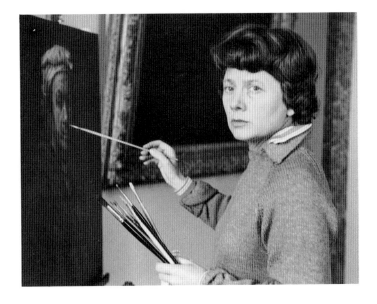

43 - Marion Pike and Christiane Lazard next to the portrait of the Lazard children, 1957

44 - Marion Pike painting Bob Hope's portrait in Malvina Hoffman's studio, Paris 1957

45 - Marion Pike painting at the Louvre, 1958

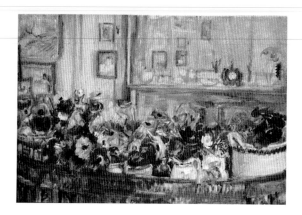

Everytime I came to see Madame Rouart, we would go, my sister and I, to Les Halles and buy her huge bunches of anemones - and then she would put them in all these pots. At one end of her living room was one of Monet's Waterlilies. Every day at four o'clock, when I was painting her, she would look up at the Monet and say *"N'est-ce pas que c'est beau!"* She told me that, after Monet was operated for his cataract, she went to see him in the hospital . He told her that when he came out of the operation he had this sensation of blue - that everything was blue. After that he painted his waterlilies.

In the dining room was this wonderful portrait of Berthe Morisot by Edouard Manet. They almost put a hole in it by opening a bottle of champagne - the cork went into the painting.

Every day somebody would bring her paintings to authenticate. One day she had a Manet on one side and a Renoir on the other. She said they were both fakes.

Marion Pike

46 - Anemones in Mme Rouart's *jardinière* Oil on canvas, 1957

47 - Madame Ernest Rouart, 1957

48 - Madame Jeanne Baudot, a friend of Mme Rouart, and the only pupil Renoir ever accepted, as she was painted by Marion Pike in 1957 (color plate #8).

49 - Marion Pike painting in Mme Rouart's living room, 1957

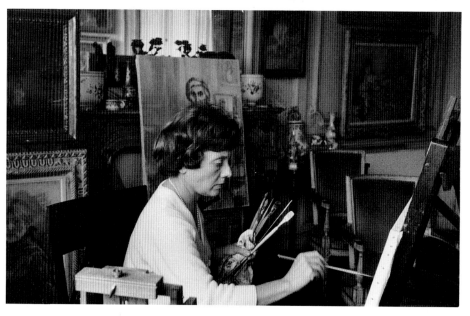

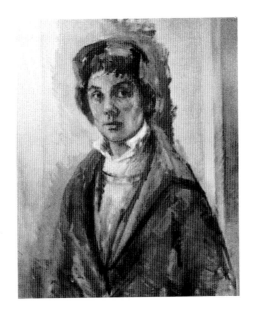

1958 (continued)

Fall – trip to South America: Argentina (portrait of Juan Raynal), Peru, Panama, Guatemala (buys a piece of land on Lake Atitlan).
Back in Paris, paints Mme Rouart.
Meets Josette Raoul-Duval.

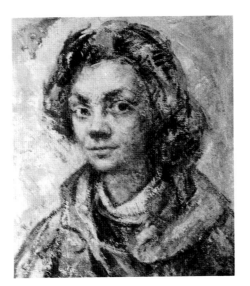

1959 Continues painting at the Louvre.
Portrait of Mme Paul Valéry.
Numerous Paris landscapes.

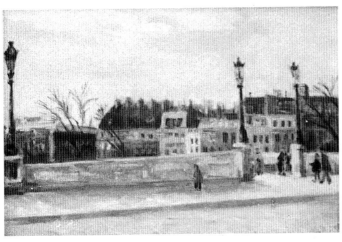

50 - Self-portrait
 Acrylic on canvas, 1958

51 - First portrait of Josette
 Acrylic on masonite, 1958

52 - On the Pont-Neuf
 Acrylic on canvas, 1958

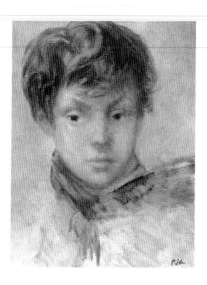

It all started with my annual flu. I was then ten and certainly not sorry for being sick. A cozy bed, the sheer pleasure of missing school, the exercise of a non-stop tyranny against my beloved mother, the full-time company of the family cat – all that made a mockery of my fever. Of course there was some downside, for me the daily injections, for my mother and the cat, to have to leave her my room, him my bed, by order of the medical corps in action.

But 1958 was to be the beginning of a fairy tale. That year antibiotics came in color tubes, needles became brushes, my medicine smelled like oil paints. Diagnosis became an art and the patient a model. Marion Pike had stepped into my room with a canvas, her easel and her genius!

She has shared our life ever since, in the apartment right above on Boulevard Saint-Germain, and then with us, rue de Nevers. Our families became for ever one and merry, with two mothers for each of their combined five children!

As I looked in amazement at this other me appearing for the first time on a canvas, a dream came alive. I was transformed into the "Little Prince" of Saint-Exupéry. I was not sure to deserve such a destiny, but the portrait was speaking for itself, I was to be crowned.

France would not remain the sole kingdom of my early portraits, for Marion always thought big. We conquered the world together, and Marion made me sit on many thrones when later, back from our trips, she would paint a "big head" of me.

Marion's studio is part of the magic. There, romantic music and operas are favorites. The decor is made of rooftops, landscapes, skies and flowers of all sizes, full of life and colors,hanging on the wall or neatly piled along them.

You are in Paris, Florence and New York at a glance. You swim in Barbados, Lake Atitlan or Capri all at once. You run through the fields of Sologne, down the slopes in Ibiza, you climb up the Alps and a few volcanos, poppies and lilies are dancing around you. You need to sit down, now you are the model!

Marion will soon brush away any shyness or apprehension for she is a team player. Indeed only for the first 'esquisse', promptly made in large strokes, and during a short period devoted to the eyes, to catch their message, will the model have to stand still and face the back of the board. The rest of the time, the portrait is made just in front of you. And while you are discussing, laughing and sometimes arguing with Marion, you witness the art of a great master.

She has an incredible appetite for work. I remember that when I was preparing the Bar exam in Paris, I posed at night, and all day long Marion studied the view from her window. In fifteen days my portrait was surrounded by no less than eleven 'Pont-Neufs' !

I have posed for Marion in shorts, pants and suits as time flew by and the child became an adolescent, then a young man. These were privileged and unforgettable moments.

When the sitting sessions are over, when you walk out the door of Marion's studio, you cannot help feeling sad for you already miss her. As we jokingly told each other once, upon leaving for some time, "See you in five minutes!" I can hear her pacing, back and forth, in front of her easel. Marion is at work, the fairy tale continues...

Pierre Raoul-Duval

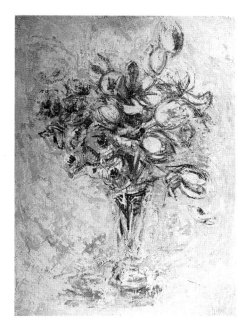

1960 Contracts pneumonia in the Louvre, and is invited to stay with the Raoul-Duvals to recuperate. The 3 children "adopt" her. Summer in Ibiza.
Meets André Malraux and Louise de Vilmorin.
Back at the Madison Hotel in November.

1961 Summer – trip to Aix-en-Provence for the music festival, where friend Suzanne Danco is singing.
First portrait of Louise de Vilmorin.
Fall – moves to a new apartment one floor above the Raoul-Duvals at 126 Boulevard Saint-Germain.
December – Josette Raoul-Duval marries Jean-Charles Devin.

1962 Winter in California.
Portraits of Wright Ludington, Norton Simon and Thomas C. Howe.
Lecture at the Los Angeles County Museum.
April-May, trip to the south of France.
June in Venice, Italy – attends the Biennale.
First paintings of the "white" period.
Back in Venice in September.
Fall – trips to Spain and Corsica.

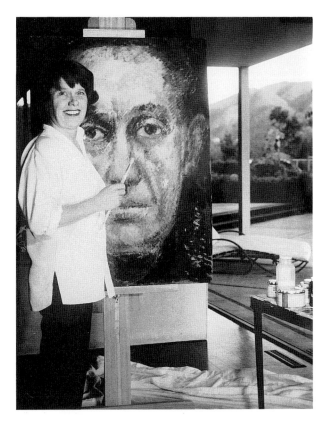

54 - *Les Fleurs Blanches*
Acrylic on masonite, 1962

55 - Marion Pike working on the portrait of Norton Simon, Los Angeles, 1962

I remember Marion coming over one night, and I asked her to paint Norton. He had a great respect for her as an artist. He wouldn't pose, but he came out and he was in his pajamas! Marion had an easel and a board, she started to paint him and he suddenly got very interested. After half an hour he sat down and said he would stay up all night.

Lucille E. Simon

33

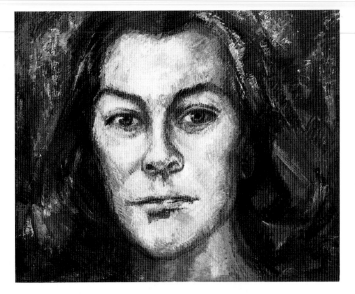

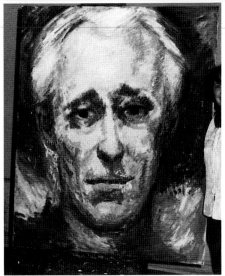

I love to be out of doors, in the sun, with the boats passing and the day so beautiful and people around – just painting what I see. The walk on the side of Venice is like walking through an old Dutch landscape, the stark architectural beauty, little canals, empty streets...

Marion Pike

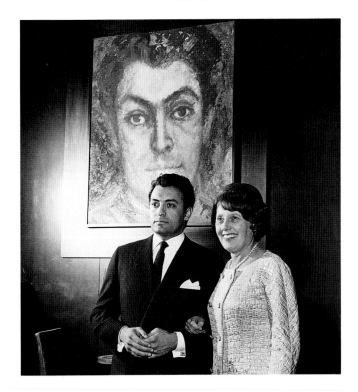

56 - Mary McCarthy
Acrylic on masonite, 1963

57 - Marion Pike working on the portrait of John Walker III, 1966

58 - Venice
Sketch on prepared board, 1966

59 - Marion Pike and Zubin Mehta at the unveiling of Mehta's portrait, 1965

Now that all the shouting is over – and what lavish and lovely *and* well-deserved 'shouting' it was – I want to tell you how proud I am of your achievement with the Mehta portrait. It is a distinguished piece of work and happily graces the distinguished setting given it.

Thomas C. Howe, Director
California Palace of the Legion of Honor
(letter to Marion Pike, November 1965)

WHAT IS MY LONGTIME FRIEND MARION PIKE TO YOU? TO ME? TO US?

...In personality she is dynamite – a short woman full of laughter, electricity, strongly stated beliefs, and warm curiosity. She is instantly fascinated by old friends and/or strangers. ("Are you happy?" she asked a Manhattan doctor I had just introduced. Instead of replying, "Are you nutty?", he answered after thought that he was indeed happy. Then he explained why.)

She dresses in low-heeled shoes – "I paint so much standing up," – and pants-suits, often in her favorite color (white). She has green eyes and cropped blonde-ish hair, and she never seems to stop painting. In the three weeks following this past Christmas, she painted 14 different paintings – mountains, skies, flowers, people.

She lives in three different homes in three different countries – France, Guatemala, and the United States. One unforgettable evening twenty years back, she invited fourteen friends to dinner in her Los Angeles home. The plan was for us to eat splendidly and then go to a concert at the University of Southern California... However, when we arrived for dinner there was none. No lights in the house, either. Where was Marion? We found her painting in her studio, lost to the world. What was in the refrigerator? One shriveled-up lemon... We knew, because we looked! But nobody really minded. The concert was excellent. After it, there was a fine Italian restaurant.

She and I have known each other for nearly a lifetime, since we met as students at Stanford University. As I look back, all things were exceedingly corny at the time: each of us was elected Queen of Stanford's Masked Ball, and each of us was given a nickname for the occasion... She was "Queen Speedball Hewlett" – I was "Queen Hey-Hey Harris." After our two separate balls were over – I got kidnapped the day I was Queen – the Masked Ball was abolished forever. No comment.

Except to say that Marion occasionally quotes Goethe's famed remark, "Spirit is the very life of life itself." To her friends, Marion Pike precisely fits that description.

Eleanor Harris Howard

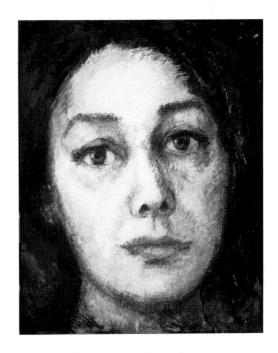

60 - Eleanor Harris Howard
Acrylic on masonite, 1966

CHRONOLOGY

1963 March-April, paints nudes.
May – trip to Greece and Crete.
Portrait of Mary McCarthy, in Paris.
Summer in Italy.

1964 June in Venice.
July – trip to French Polynesia.
August in California.
Fall – trip to Spain with Norton and Lucille Simon.

1965 Portrait of Zubin Mehta for the Dorothy Chandler Pavilion, at the Los Angeles Music Center.
Portraits of Lucille Simon and Justin Dart.

1966 April-May – trip to the South of France
June in Venice for the Biennale – portrait of Alberto Giacometti.
Meets Magdeleine Hours, then head of the laboratory at the Louvre.
October – Time Magazine cover portrait of Ronald Reagan, then running for governor of California.
December – trip to Egypt.

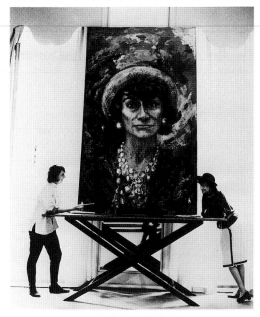

Angeleno Paints Her Way
Into the Coco Chanel Legend

Coco Chanel, she of the obsidian eyes, the tart tongue and the vital flair, was legend at 22. At 85 she is one of the world's true uniques [...] It has been Marion Pike's rare luck, inspiration and delight to have spent the last seven months in Coco Chanel's salon on the rue Cambon in Paris.

...Marion's two portraits, one of Chanel alone and the other of her amidst bolts of materials and the bustle of the atelier, are the only existing portraits Chanel ever posed for. Picasso asked her many times; she did sit once for Forain, but that one is missing. And the portrait ascribed to Marie Laurencin, Melle Chanel denies.

Chanel really only "sat" for Marion Pike once ... The rest of the time Marion "caught" Chanel in odd moments and flashes, as the sprightly, irrepressible octogenarian sat on the stairs, pensively watching the models, or leaped up to rip out a seam, or alternately praised and scolded as the collection slowly and painfully took shape. "The atmosphere was frayed nerves, excitement, enthusiasm, frustration, gloom and energy. It was like the creation of a Broadway show: inspiration, chaos, and seemingly endless perfecting," says Marion...

by Maggie Savoy
Excerpts from the Los Angeles Times, December 2, 1967

From top :

61 - Coco Chanel and Marion Pike next to Chanel's portrait, Paris,1967

62 - Marion Pike's painting of Chanel in her atelier appears in the background of Vogue Magazine's coverage of Chanel's collection, 1967

63 - Chemin de la Pacaudière, Sologne
Acrylic on masonite, 1967

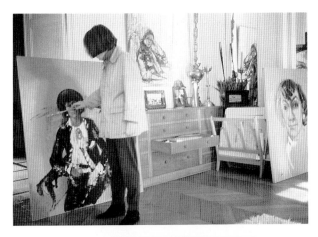

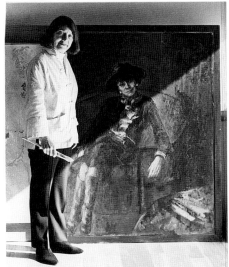

1967 In February, meets Gabrielle "Coco" Chanel.
Starts two large portraits.
March – trip to Morocco.
Numerous commissions – Portraits of
Magdeleine Hours and Frank Perls.
Summer – first stays in Sologne, and trip to
Southeast Asia.
September – trip to Switzerland with Chanel.

1968 April-May – paints several portraits of Chanel
during the *May '68 revolution* in Paris.
Another trip to Switzerland with Chanel.
July – Portrait of pianist Arthur Rubinstein
at his home in Marbella, Spain.
August in Sologne. Numerous landscapes.
In the fall, exhibition of the Chanel portraits
in Paris.

1969 Winter in California and the Southwest.
Plans for the construction of a new studio in
Los Angeles.
May – first trip to Barbados to visit Claudette
Colbert.
June in Italy.
In September, trip to Amsterdam for the
Rembrandt Tricentennial.

1970 March in Barbados
May - trip to Switzerland and Italy.
First giant florals (Gloxinias).
Finishes a large self-portrait – possibly the
largest ever painted.
July – trip to Turkey and Iran.
September – Sologne and a trip on the canals
to Brittany.
October - trip to Holland, Belgium and
Germany.
December – trip to Madrid.

Marion is a gifted painter in every field she
chooses. Her huge flowers are unique. I have
been fascinated watching her paint clouds for
hours here on my beach in Barbados.

Claudette Colbert

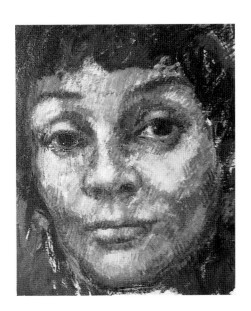

64 - Marion Pike working on a portrait of Chanel, 1968

65 - Marion Pike and her portrait of Chanel seated, 1968

66 - Portrait of Claudette Colbert
Acrylic on masonite, 1970

37

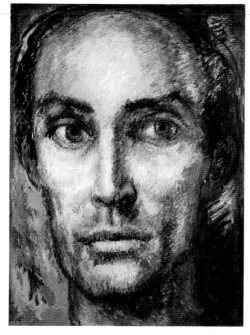

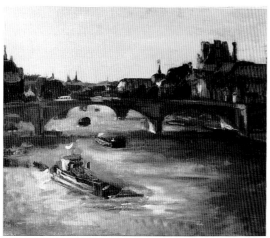

67 - Portrait of Gilberto Zabert
 Acrylic on masonite, 1972

68 - Capri
 Acrylic on masonite, 1972

69 - Pont du Carrousel, Paris
 Acrylic on cardboard, 1971

70 - Notre-Dame at night
 Acrylic on paper, 1971

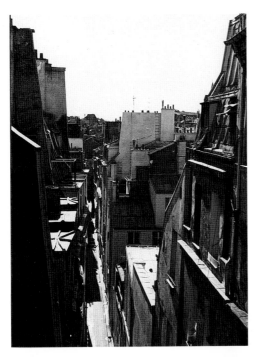

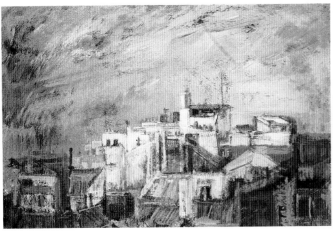

1971 January in Barbados.
 Death of Coco Chanel.
 February, Jean-Charles Devin, Josette's
 husband, dies in an auto accident.
 Starts construction of the new studio in
 Los Angeles.
 Summer in Sologne.
 October – moves to rue de Nevers.
 Numerous views of Paris rooftops.
 November in Italy.
 December – trip to Russia.

1972 May-June, exhibits at the Galleria
 Zabert in Torino.
 June – Florence, Venice, Capri.
 Summer in California with trips to
 Mexico and Hawaii.

71 - View of the rue de Nevers from
 Marion Pike's studio in Paris.

72 - Paris rooftops
 Acrylic on masonite, 1971

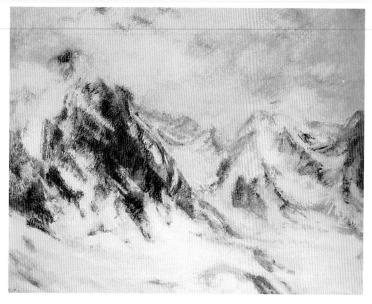

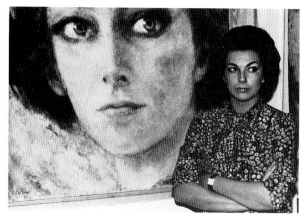

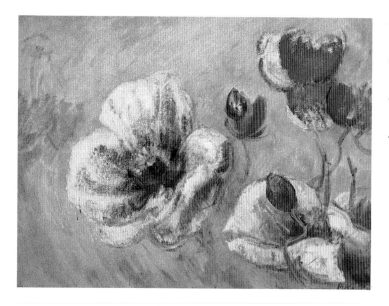

73 - Mont-Blanc, from Le Lavanchet, France
Acrylic on masonite, 1973

74 - French countryside, Crécy-Couvé, France
Acrylic on masonite, 1974

75 - Giant poppies
Acrylic on canvas, circa 1974

76 - Princess Barbara of Yugoslavia next to her
portrait, Paris, 1975

1973 January in Los Angeles – portrait of
Mrs.Patrick Frawley, 3 large studies of
Dolores Hope.
March - trip to Le Lavanchet, near
Chamonix, in the French Alps.
Numerous mountain landscapes.
Second portrait of Arthur Rubinstein.
April in Barbados.
Summer in Paris, Sologne, and on the
French Riviera.

1974 February in Florida – exhibits at the
Palm Beach Galleries.
June - trip to Panama, Venezuela and
Barbados.
Summer - Sologne and Crécy-Couvé.
First paintings of Poppies.
Fall– trip to India (meets André Malraux
in Bombay).
Starts construction of a studio in
Guatemala.

1975 February - second stay in the French
Alps.
May in Sologne.
August in Barbados.
October - trip to Colorado, to do
portrait commissions.
Winter in California.

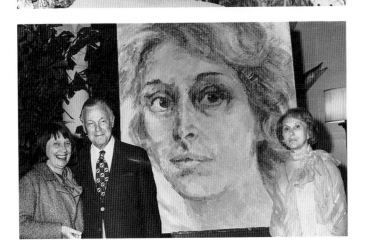

77 - Marion Pike with Bob Hope in a golf
tournament, 1973

78 - Marion Pike working on William Murray's
portrait in Palm Beach, 1974

79 - Joseph and Estée Lauder next to Estée Lauder's
portrait with Marion Pike, 1974

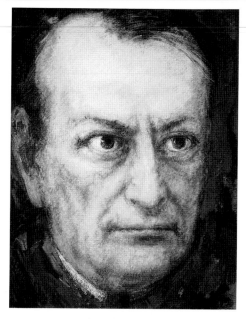

Even among those who genuinely appreciate painting there are many who fail, until confronted with their own face, to understand this curious alchemy of the painter, which makes their loss his gain.

André Malraux, *The Voices of Silence* (translation Stuart Gilbert)

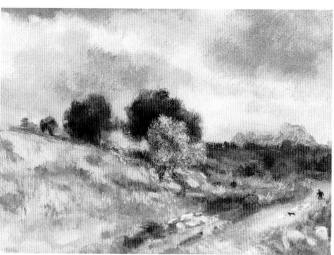

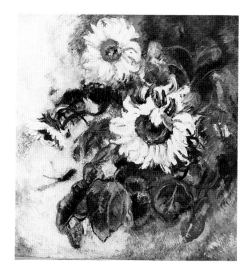

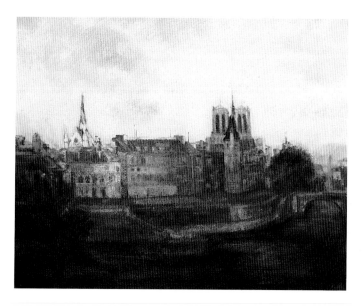

80 - André Malraux
 Acrylic on masonite, 1976-78

81 - Corsica
 Acrylic on paper, 1976

82 - Sunflowers
 Acrylic on masonite, 1978

83 - Ile de la Cité, Paris
 Acrylic on masonite, 1977

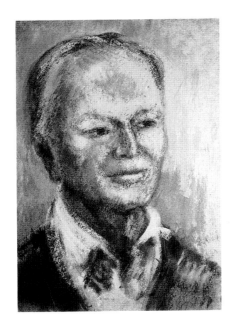

1976 April - trip to Salzburg and Munich
July – trip to Auvergne – several landscapes.
July - completion of house and studio in Guatemala.
August in Barbados.
Fall - André Malraux dies. Pike goes straight home from the state funeral at the Louvre and paints his portrait from memory.

1977 July – trip to England, starts a portrait of Kenneth Clark.
October - Barbados.
November - second exhibition in Palm Beach, Florida.

1978 January in California.
February in Guatemala.
March in Barbados.
May-June - Trip to Southeast Asia and China.
August in Sologne.
October - trip to Italy.
End of year in California.

84 - Sketch for the portrait of Kenneth Clark
 Acrylic on paper, 1977

85 - Marion Pike's house on Lake Atitlan, Guatemala.

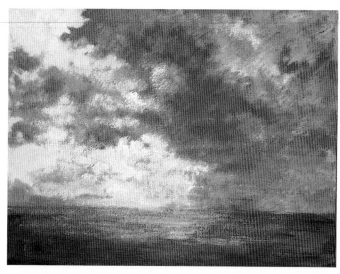

Counterclockwise from left :

86 - Seascape
Acrylic on canvas, 1982

87 - Paris, *La Cité* at night
Acrylic on masonite, 1980

88 - Flowerbed at Giverny
Oil on canvas, 1985

89 - Iris
Oil on canvas, 1981

90 - Giant Lilies
Acrylic on masonite, 1980

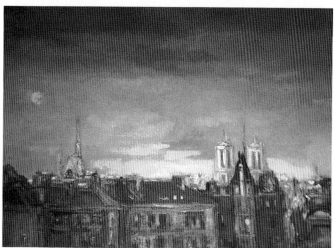

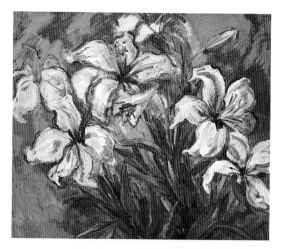

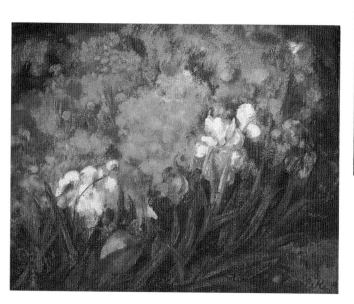

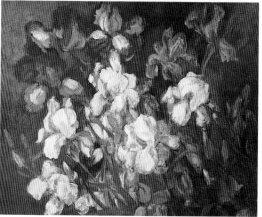

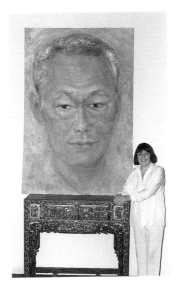

1979 March in Guatemala – several paintings of Lake Atitlan.
Summer - Frequent trips to Sologne.

1980 February - Portrait of André Desmarais, in Canada.
April in California and New Mexico.
August - paintings of Monet's garden at Giverny.
First Great Lilies and Pont-Neuf at night.
November in Barbados.

1981 April - trip to New Mexico and Colorado.
Summer - second trip on French canals.
Numerous views of Paris and the Seine.
First paintings of Irises.
November – Portrait of Singapore's Prime Minister Lee Kwan Yew.
Trip to Indonesia and Japan.

1982 January in California.
February in Switzerland.
April in Florence.
In May, travels throughout Italy, Austria and Germany – following the itinerary of Montaigne's "Voyage en Italie".
Summer in Canada (portrait of Paul Desmarais) – and Barbados.
In the fall, starts portrait of Pope John Paul II. Attends several audiences at the Vatican in Rome.

1983 February – Washington, portrait of Nancy Reagan at the White House.
August - finishes portrait of the Pope.
October - trip to Italy.
Giant Flowers: Lilies, Camelia, Gloxinia.
Kenneth Clark dies - his portrait is not finished.

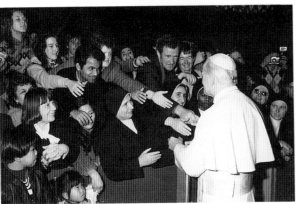

91 - Marion Pike next to Lee Kwan Yew's portrait
 Singapore, 1981

92 - Monet's garden at Giverny

93 - Marion Pike attending a papal audience
 (lower left, with white scarf), 1982

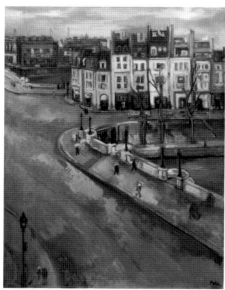

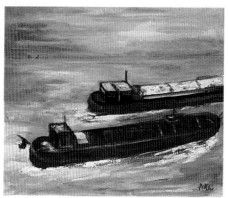

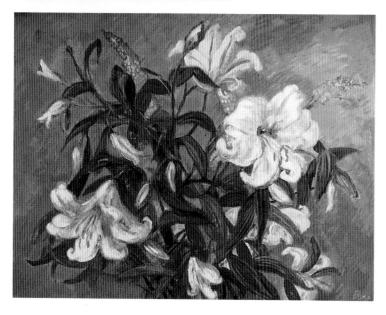

From top :

94 - John Wayne on the set
Sketch, 1985

95 - Portrait of France Desmarais
Acrylic on masonite, 1984

96 - Pont-Neuf in the rain
Acrylic on canvas, 1989

97 - Barges on the Seine
Acrylic on masonite, 1987

98 - Large Lilies
Acrylic on masonite, 1988

99 - Marion Pike in her studio in Guatemala, 1987

100 - Marion Pike (right) with her long-time friend Ted Gibson
 in Gibson's art supplies store, Los Angeles.

1984 March in Barbados.
 July in Sologne.
 New representations of the Pont-Neuf
 and the Seine, with figures and barges.
 September in Canada and California.

1985 February - 3 portraits of John Wayne.
 March in Barbados.
 June in Florence.
 End of year in Guatemala.

1986 January in New York - portrait of Licia
 Albanese for the Metropolitan Opera.
 June in Barbados.
 Summer in Guatemala.
 November, exhibits at El Paso Museum.

1987 Spends winter in Guatemala.
 June – trip to Switzerland and Italy.
 November - New York, then California.

1988 Winter in Guatemala.
 June – several paintings of Lilies.
 August – trips to Normandy and
 Sologne.
 December in New York and California.

1989 January-April – Works on catalog.
 August in Barbados.
 September in Guatemala.
 In the fall, exhibits in Scottsdale
 Arizona, and Denver, Colorado.

1990 Spends the winter in California.
 Pont-Neufs with figures, large skies.
 February - exhibits at the Retrospective
 Gallery, in La Jolla, California.
 August – trip to Canada to do portrait of
 Prime Minister Brian Mulroney.

COLOR PLATES

No loose edges, no tricks –
just solid paintings and values.

Marion Pike

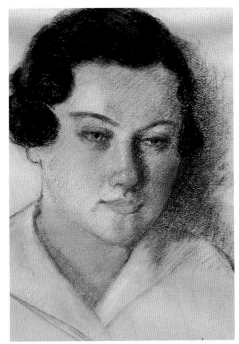

1
Portrait of Jane Hewlett
Signed, 1933
Pencil on paper
35 x 28 cm (13 3/4" x 11")

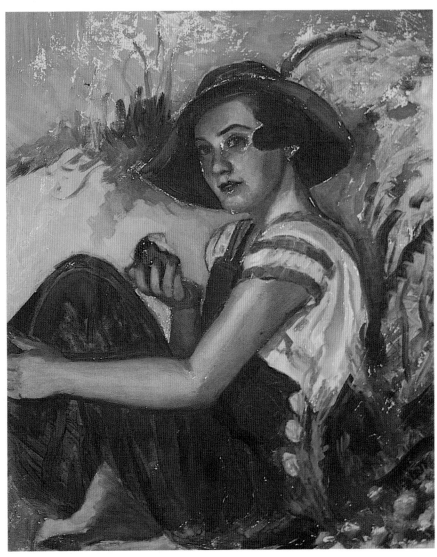

2
Jane on the beach
1934 (damaged)
Oil on canvas
76 x 63 cm (30 " x 24 3/4")

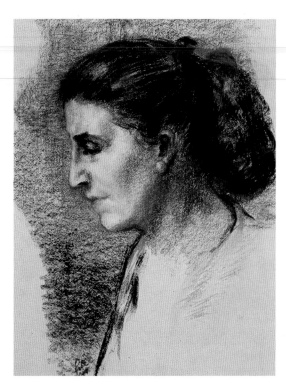

3
Licia Albanese
Signed and dated, 1944
Pastel on paper
49 x 37 cm (19 1/$_4$" x 14 1/$_2$")

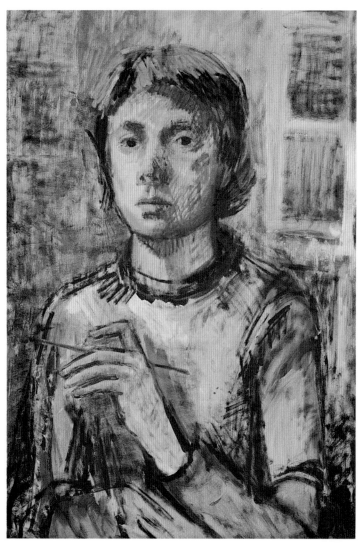

4
Self-portrait
1952
Acrylic on masonite
76 x 51 cm (30" x 20")

5
Cornelia Runyon
Large Head – 1954
Acrylic on masonite
76 x 56 cm (30" x 22")

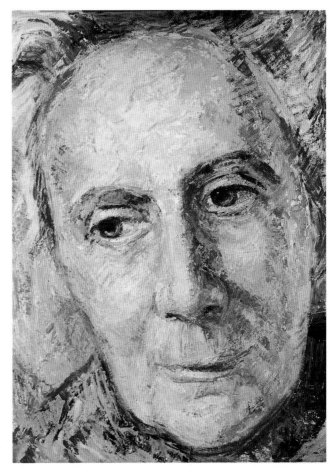

6
Large Floral
1955
Oil on canvas
116 x 150 cm (45 1/$_4$" x 59")

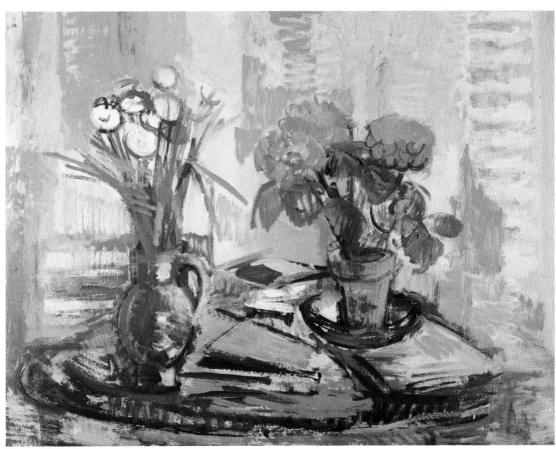

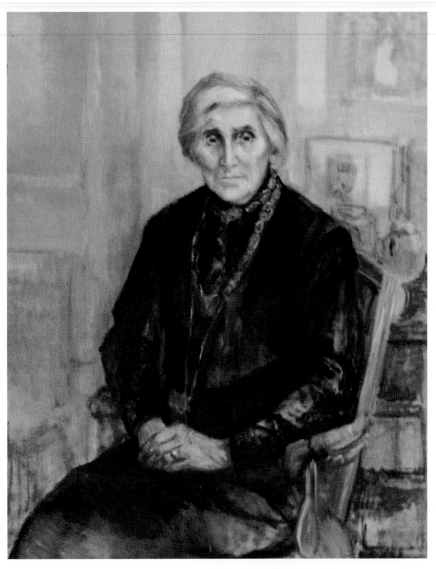

7
Mme Ernest Rouart
Née Julie Manet, 1957
Oil on canvas
92 x 72 cm (36" x 28 $^3/_8$")

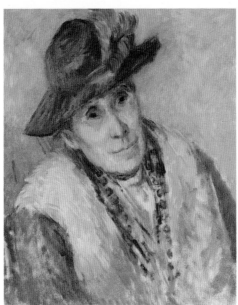

8
Jeanne Baudot
1957
Oil on canvas
54 x 45 cm (21 $^1/_4$" x 17 $^3/_4$")

9
Mmes Ernest Rouart & Paul Valéry
1963
Acrylic on masonite
125 x 165 cm (49 $^1/_4$" x 65")

10
Le Garçon de Café (The Waiter)
Paris, 1958
Oil on canvas
162 x 97 cm (63 $^3/_4$" x 38 $^1/_8$")

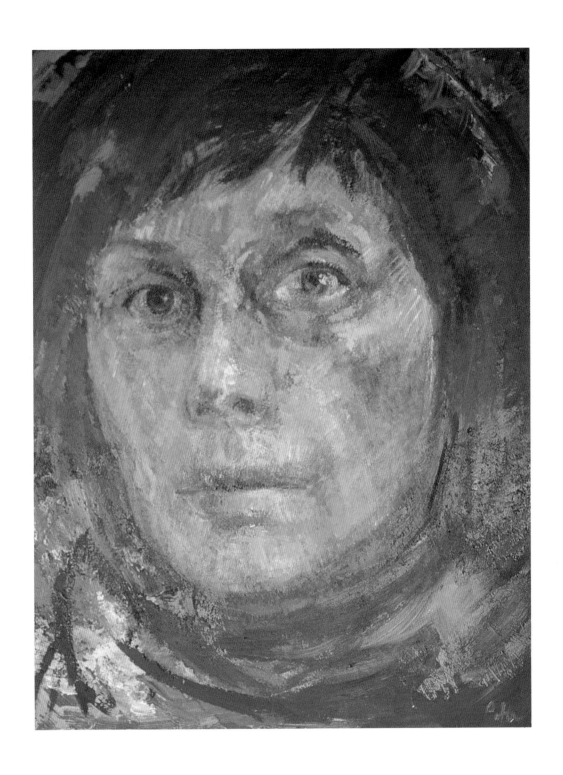

11
Self-portrait
Large Head – 1960
Acrylic on masonite
116 x 89 cm (45 $^5/_8$" x 35")

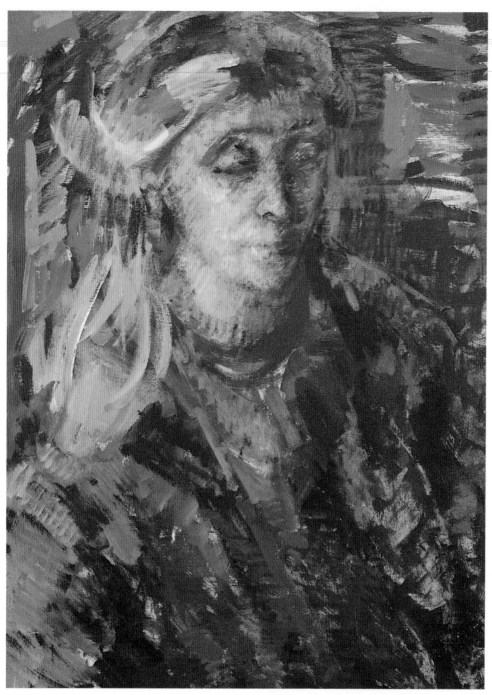

12
Louise reading
1961
Acrylic on masonite
98 x 71 cm (38 $^1/_2$" x 28")

13 (facing page)
Autumn
Large Head – signed, 1961
Acrylic on masonite
163 x 115 cm (64 $^1/_8$" x 45 $^1/_8$")

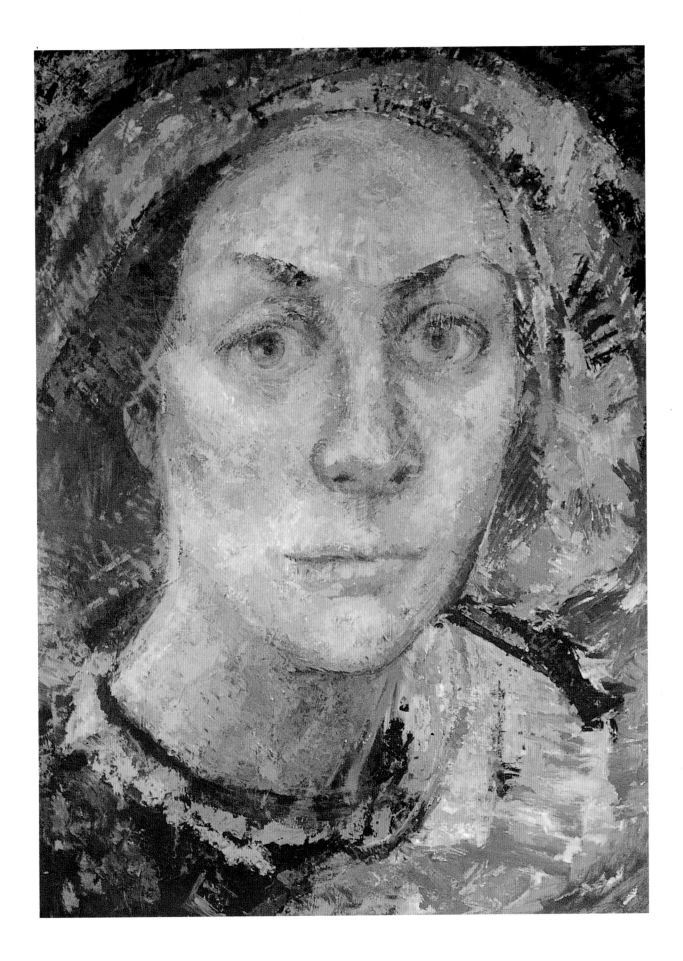

14
Self-portrait in white
Signed, 1962
Acrylic on masonite
62 x 46 cm (24 $^3/_8$" x 18 $^1/_8$")

15
White floral
1962
Acrylic on masonite
72 x 62 cm (28 $^3/_8$" x 24 $^3/_8$")

16
Vaucluse
France, 1962
Oil on canvas
58 x 72 cm (38 $^1/_2$" x 50 $^3/_8$")

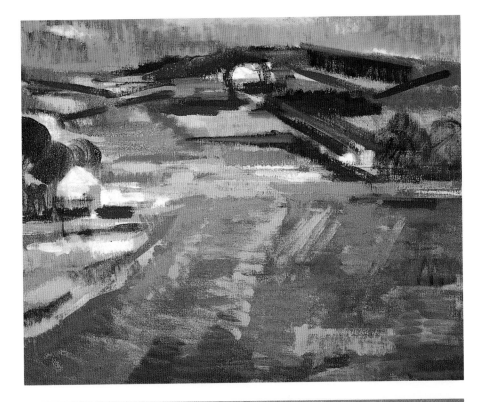

17
Paris rooftops
Signed, 1965
Oil and acrylic on canvas
98 x 128 cm (38 $^1/_2$" x 50 $^3/_8$")

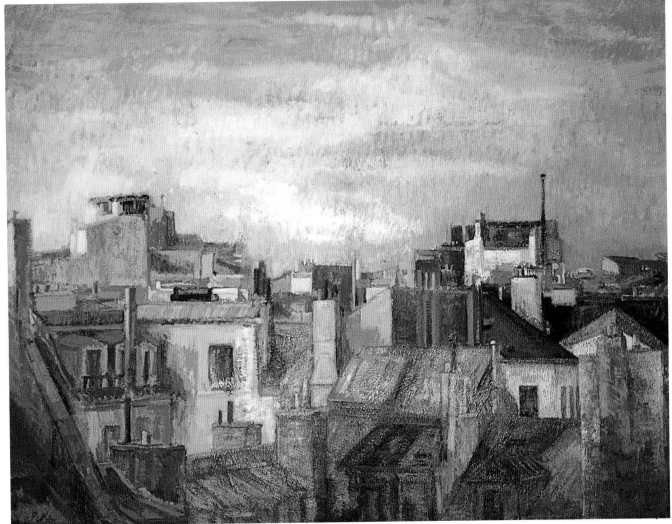

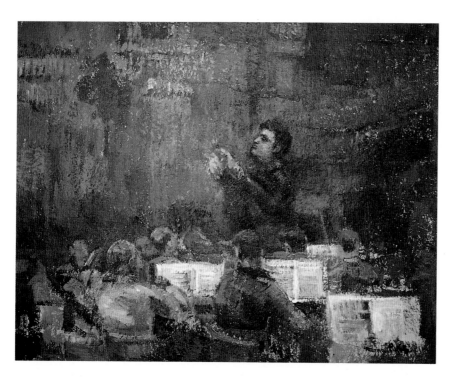

18
Zubin Mehta at rehearsal
Signed, 1965
Acrylic on paper
48 x 61 cm (18 $^7/_2$" x 24")

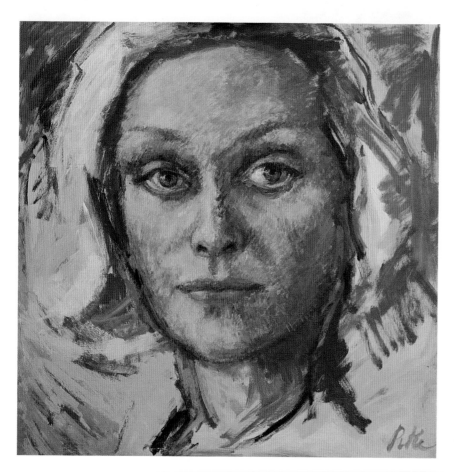

19
Jean Howard
Large Head – signed, 1965
Acrylic on masonite
122 x 122 cm (48" x 48")

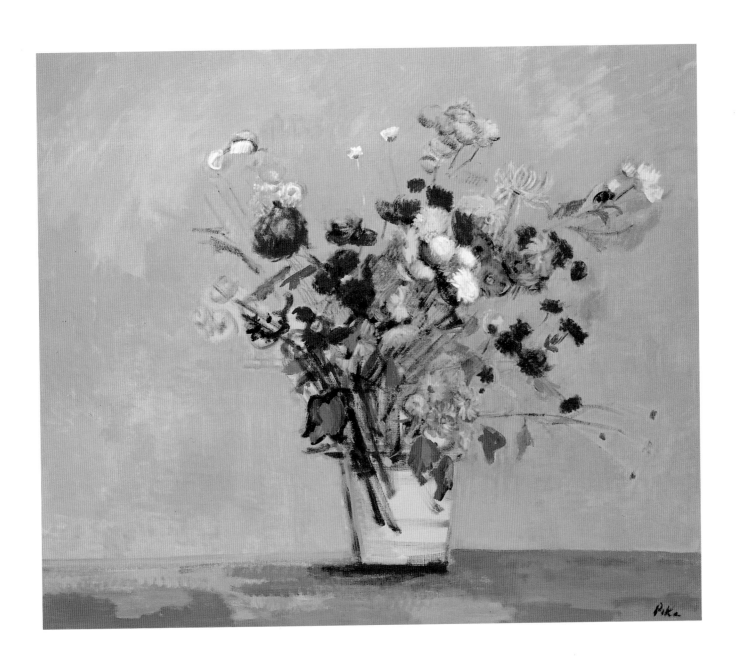

20
Large floral
Signed, 1965
Acrylic on canvas
122 x 152 cm (48" x 59 $^7/_8$")

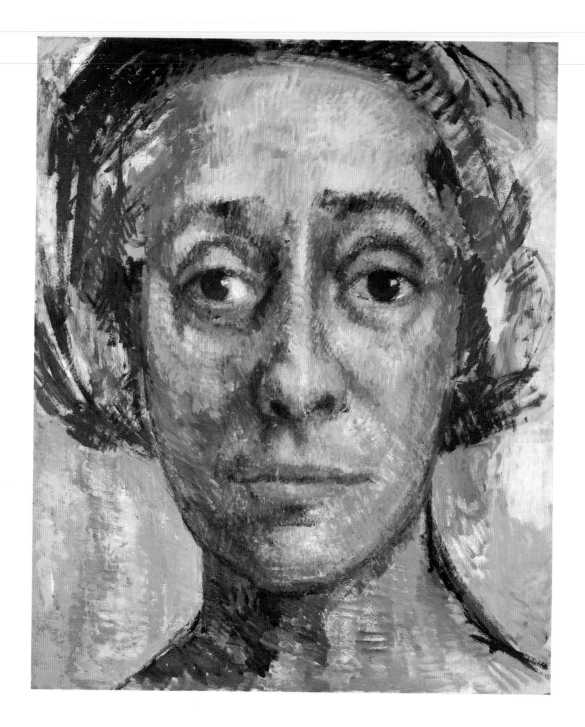

"The most important thing to me about my love for paintings is, having watched Marion paint – it opened my mind and my heart. I think it's an important statement – and it's true. Marion changed my whole idea about paintings. After spending time with her and watching her paint, I became much more interested in the process of painting – in the creative process she manifested. It opened a whole new vista, something I never thought of before, much less lived through, and it took me to depths I never believed I could go to. It was so inspirational, I cannot even explain it. And I came across the statement – that to be a great artist is to *appropriate* God."

Lucille E. Simon

21
Lucille E. Simon
Large Head – 1966
Acrylic on masonite
122 x 100 cm (48" x 39 $^3/_8$")

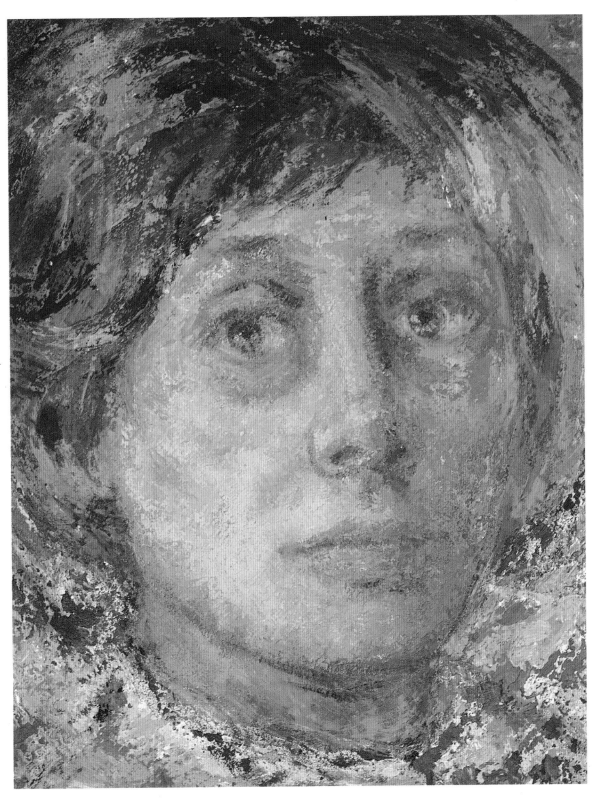

22
Self-portrait
Large Head – signed, 1965
Acrylic on masonite
115 x 89 cm (45 $^1/4$" x 35")

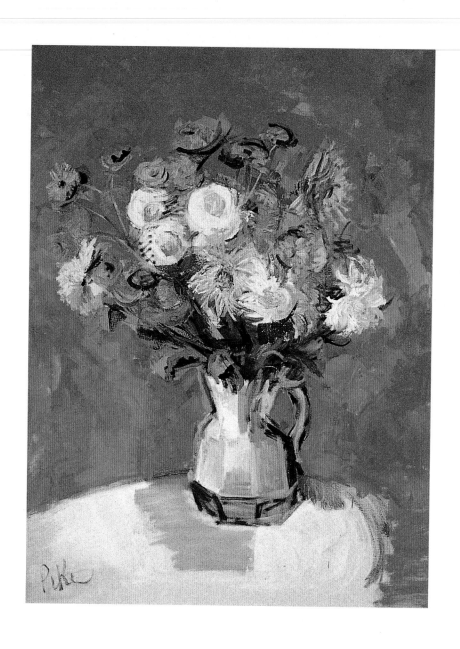

23
Blue floral
Signed, 1966
Acrylic on canvas
98 x 74 cm (38 $^1/_2$" x 29 $^1/_8$")

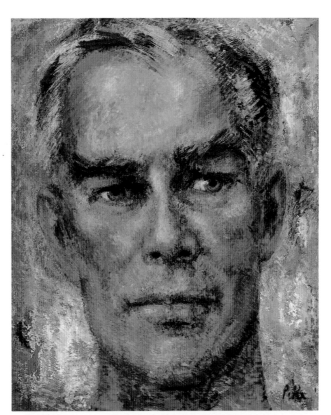

24
Justin Dart
Large Head – signed, 1965
Acrylic on masonite
152 x 127 cm (60" x 50")

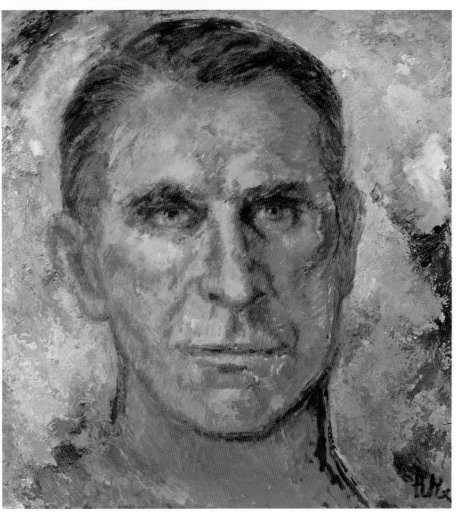

25
Thomas P. Pike
Large Head – signed, 1960
Acrylic on masonite
120 x 114 cm (47 $^1/_4$" x 45")

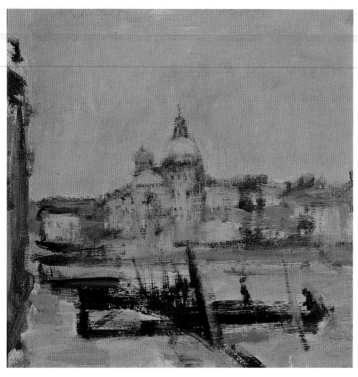

26
Venice
1966
Acrylic on paper
36 x 36 cm (14 $^1/_8$" x 14 $^1/_8$")

27
Venice – San Giorgio Maggiore
Signed, 1972
Acrylic on paper
41 x 54 cm (16 $^1/_8$" x 21 $^1/_4$")

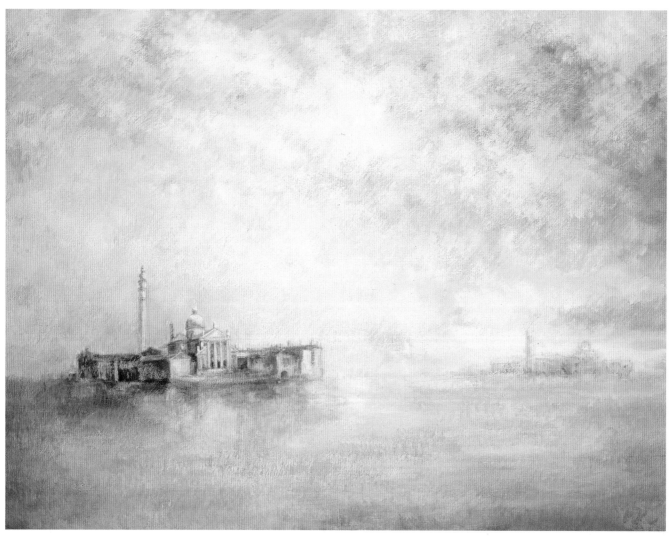

28
Venice – La Salute
1966
Acrylic on paper
21 x 26 cm (8 1/$_4$" x 10 1/$_4$")

29
Venice – Piazza San Marco
Signed, 1972
Acrylic on paper
50 x 65 cm (19 3/$_4$" x 25 5/$_8$")

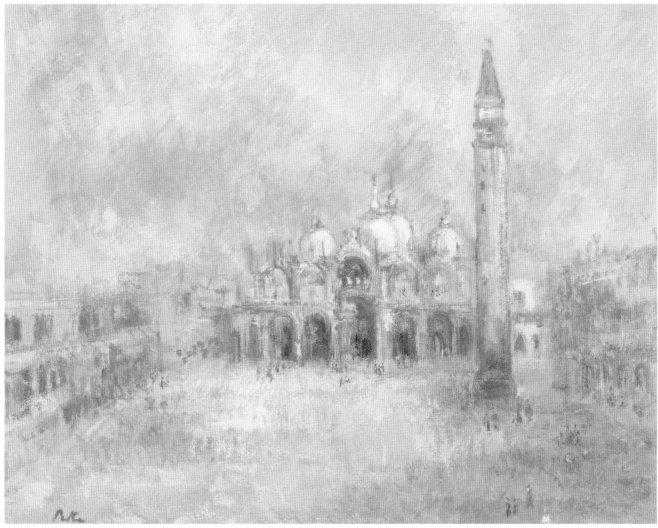

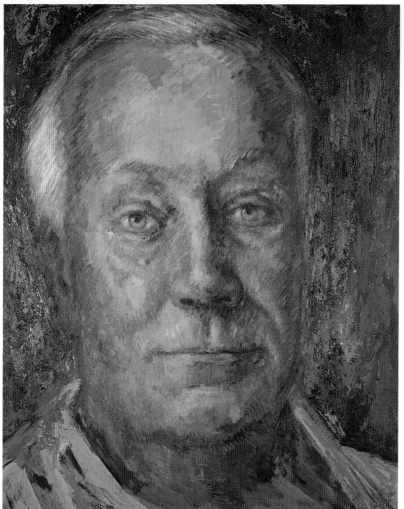

30 (above left)
Doogie Boocock
Large Head – 1966
Acrylic on masonite
148 x 123 cm (58 $^1/_4$" x 48 $^3/_8$")

31 (above right)
Mervyn LeRoy
Signed, 1968 – Acrylic on masonite
135 x 100 cm (53 $^1/_8$" x 39 $^3/_8$")

32 (left)
Howard Ahmanson
Large Head – signed, 1968
Acrylic on masonite
152 x 125 cm (59 $^3/_4$" x 49 $^1/_4$")

"Marion Pike has the ability to capture and paint the spirit and special aura of people in her unique style of painting. My husband, Howard Ahmanson, had admired the portraits which Marion had done of his friends, especially those of Justin Dart and Norton Simon. One day, in early 1968, he asked me to arrange a "sitting date" as he, too, wanted Marion to do his portrait as well – which I did. Marion's intellect, insightful thoughts, and ability to articulate in an economy of words which are concise, meaningful and honest, made the sitting exciting and a pleasure for both of us. Unfortunately, my husband never saw the finished portrait."

Caroline L. Ahmanson

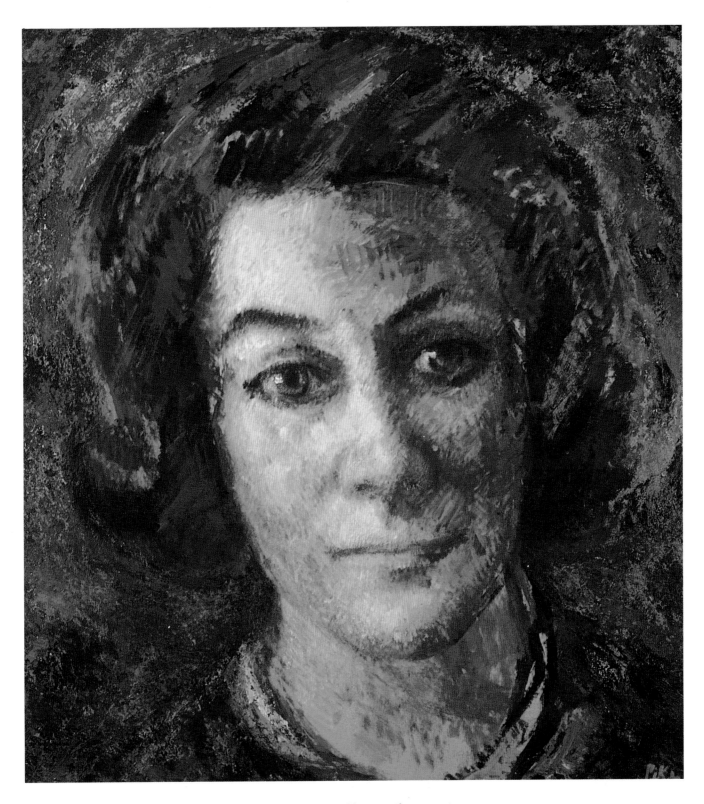

"I met Marion Pike in the Louvre more than 30 years ago. She was then copying the old masters – essentially Rembrandt – with care and fervor. From these studies she acquired the *beau métier* – a thick *impasto*, a flexible brush stroke. Many years later, I sat for her. There again I found her attentive, with this focused energy, her trademark, which allows her to reveal the deep identity of her model. The melancholy that can be read in my portrait, she found; it existed despite the exciting work that was mine at that time."

Magdeleine Hours
Former Director of the Louvre, Paris

33
Magdeleine Hours
Large Head – signed, 1968
Acrylic on masonite
114 x 106 cm (44 $^7/_8$" x 41 $^3/_4$")

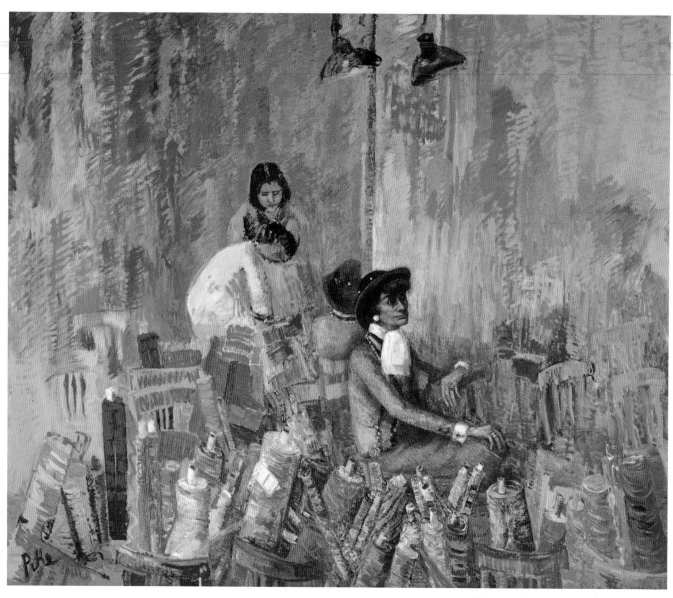

34
Coco Chanel in her studio
Signed, 1967
Acrylic on masonite
255 x 300 cm (99" x 118")

35 (facing page)
Coco Chanel
Large Head – signed, 1967
Acrylic on masonite
250 x 150 cm (97" x 59")

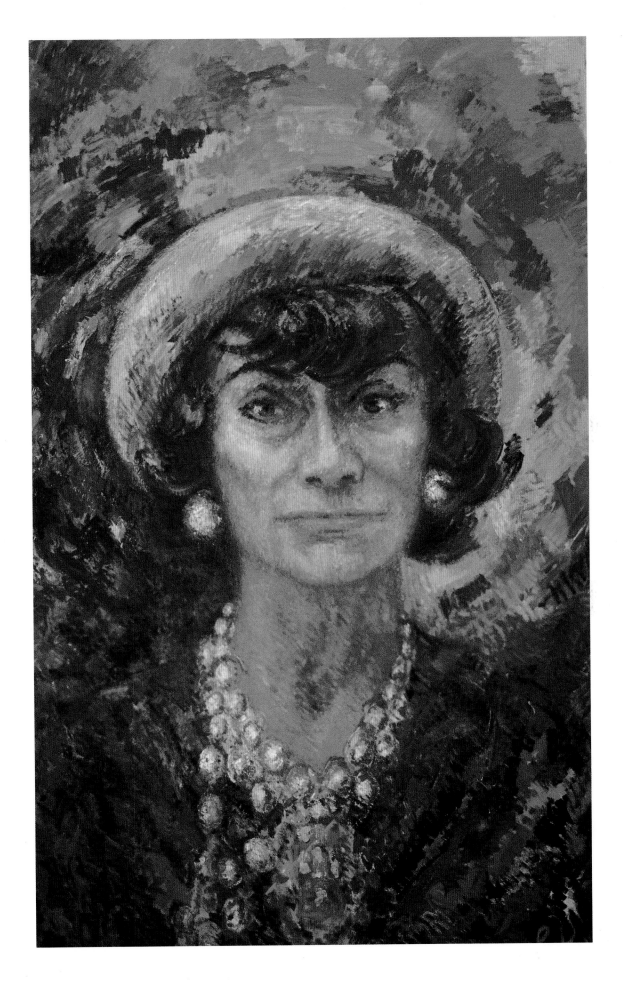

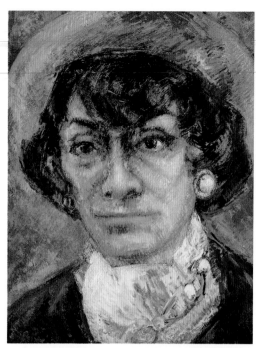

36
Coco Chanel
Large Head – signed, 1968
Oil and acrylic on masonite
133 x 102 cm (52 3/8" x 40 1/8")

37 (below)
Coco Chanel seated
Signed, 1968
Acrylic on masonite
137 x 121 cm (54" x 47 5/8")

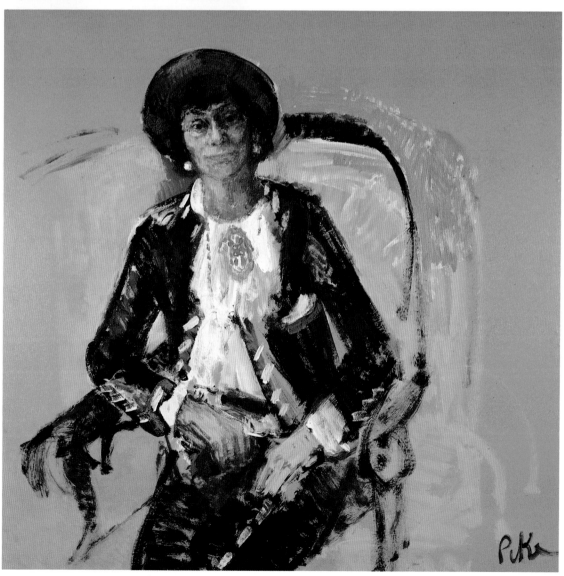

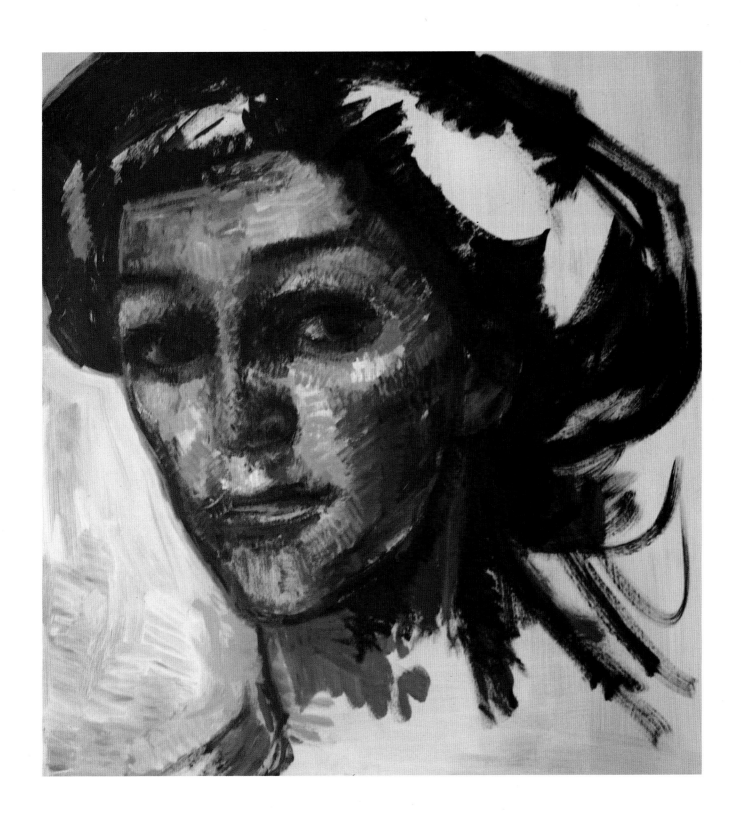

38
Louise de Vilmorin
Large Head – signed, 1965
Acrylic on masonite
125 x 115 cm (49 1/$_4$" x 45 1/$_4$")

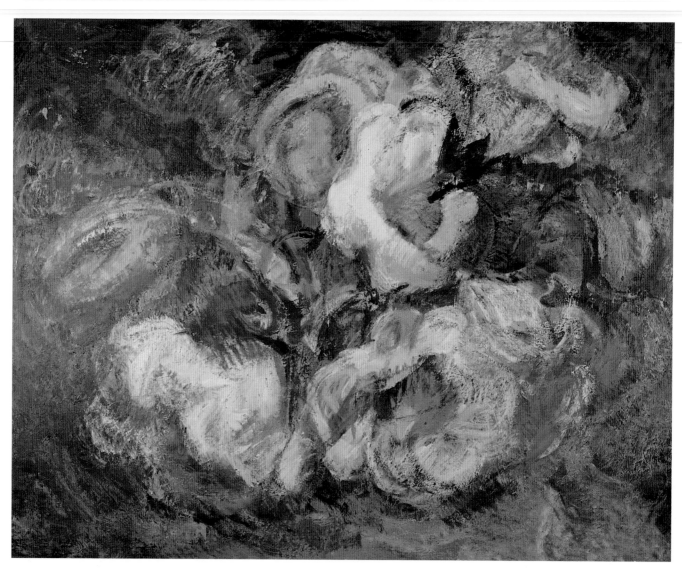

39
Large Gloxinia
Signed, 1970
Acrylic on masonite
146 x 174 cm (57 $^1/_2$" x 68 $^1/_2$")

40 (facing page)
Self-portrait
Large Head – signed, 1970
Acrylic on masonite
193 x 166 cm (76" x 65 $^3/_8$")

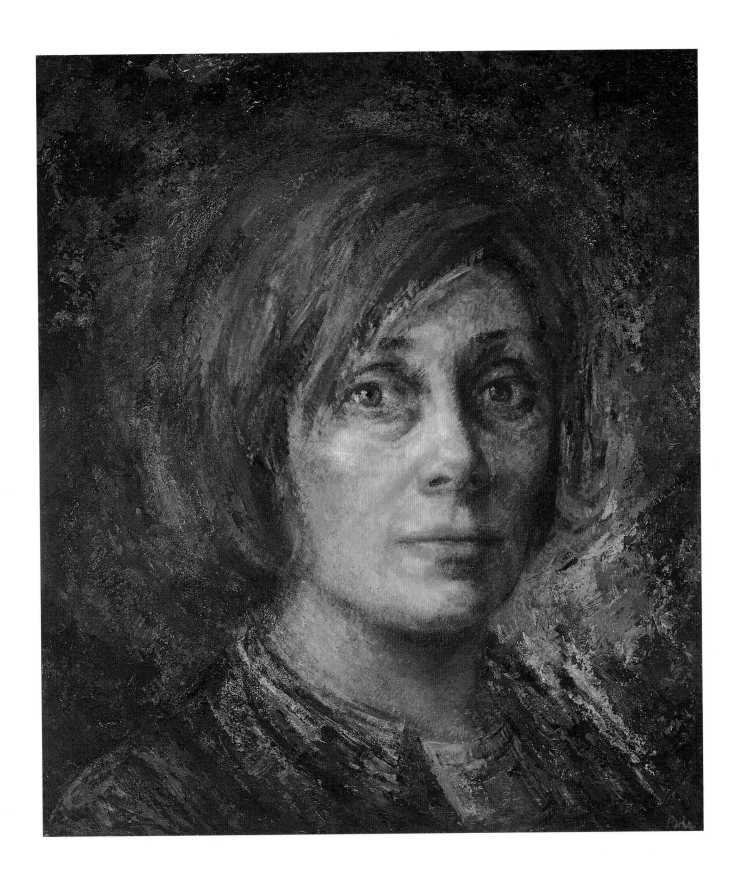

"Deep inside, art is of no time."
Marion Pike

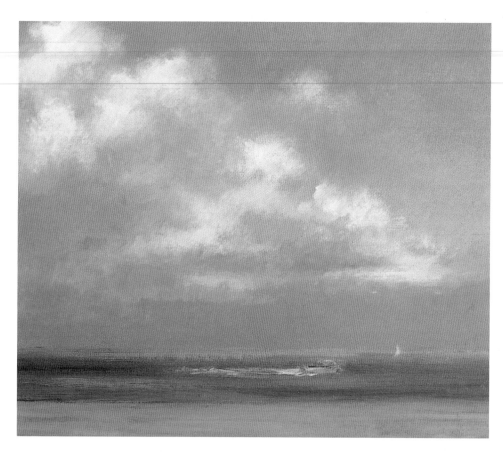

41
Barbados
Signed, 1973
Acrylic on paper
25 x 30 cm (9 $^7/_8$" x 11 $^7/_8$")

42
Barbados
Signed, 1973
Acrylic on paper
24 x 35 cm (9 $^1/_2$" x 13 $^7/_8$")

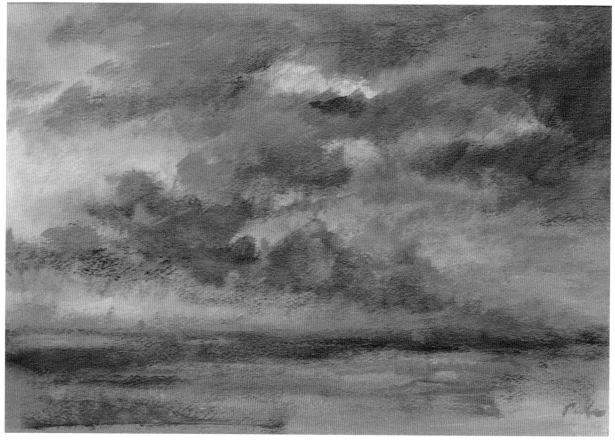

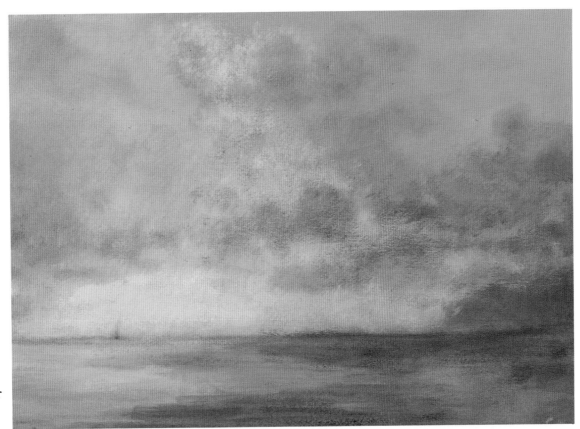

43
Barbados
Signed, 1971
Acrylic/paper
25 x 30 cm
(9 $^7/_8$" x 11 $^7/_8$")

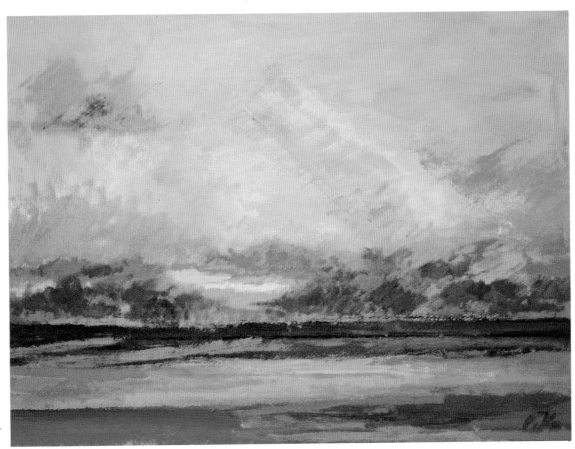

44
Barbados
Signed, 1973
Acrylic/paper
24 x 32 cm
(9 $^1/_2$" x 12 $^5/_8$")

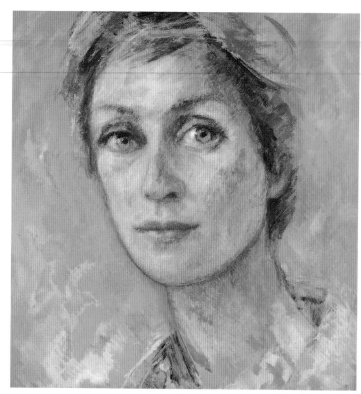

45
Jeffie
Large Head – signed, 1970
Acrylic on masonite
115 x 107 cm (45 $^1/_4$" x 42 $^1/_8$")

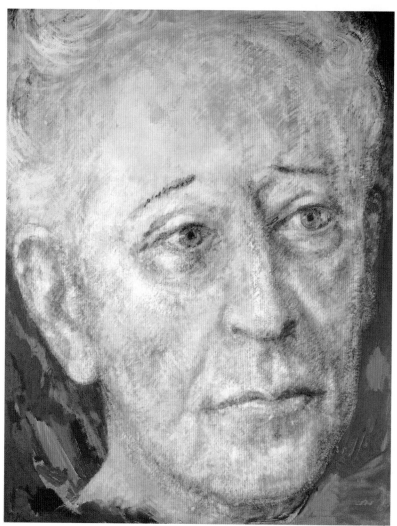

46
Arthur Rubinstein
Large Head – signed, 1971
Acrylic on masonite
160 x 125 cm (63" x 49 $^1/_4$")

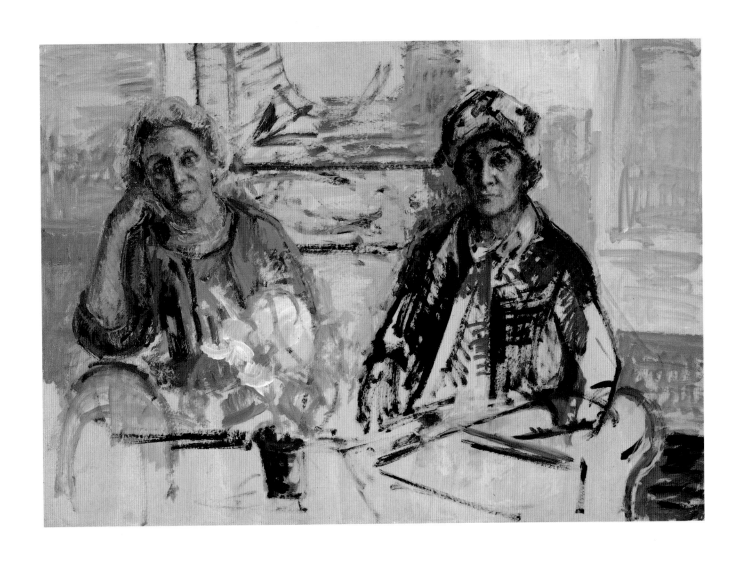

47
Phyllis Tucker and Helen Cameron
Nées De Young, 1970
Acrylic on masonite
114 x 162 cm (44 $^7/_8$" x 63 $^3/_4$")

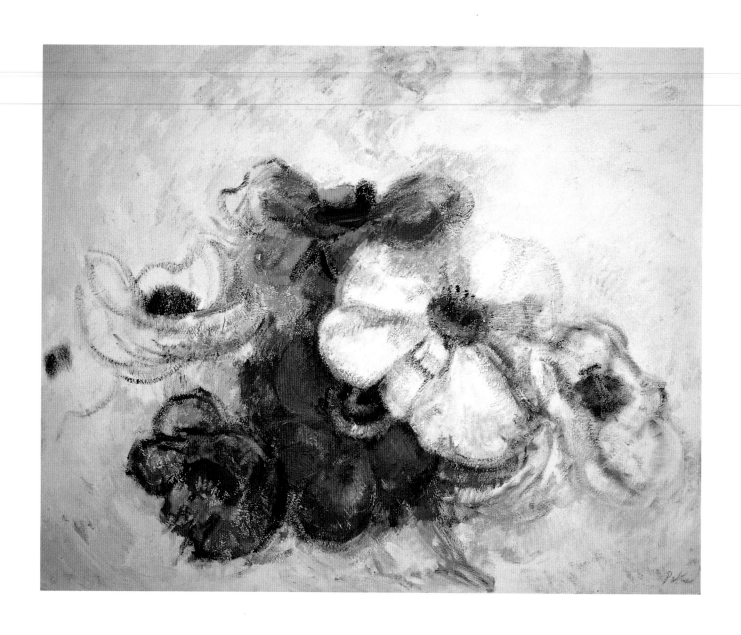

48
Large floral
Signed, 1973
Acrylic on masonite
102 x 126 cm (40 $^1/_8$" x 49 $^1/_2$")

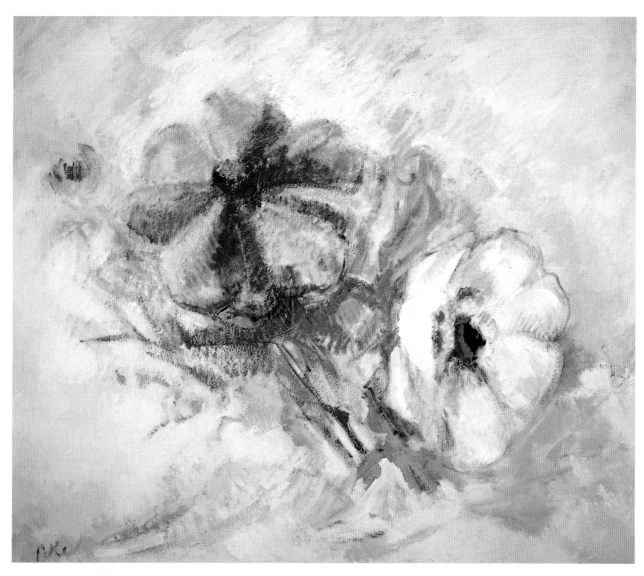

49
Large floral
Signed, 1973
Acrylic on masonite
108 x 130 cm (42 1/$_2$" x 51 1/$_8$")

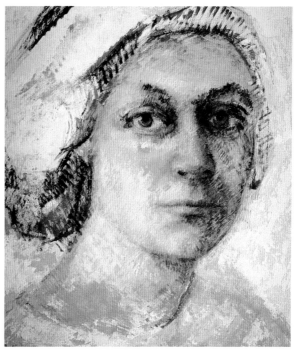

"Pensive gravity of the Fayum art...It has learned the secret of a gaze that is not the expression of a fleeting moment. [These portraits] go beyond mere imitation in their likenesses."

André Malraux

50
Josette
Large Head – signed, 1971
Acrylic on masonite
138 x 125 cm (54 1/$_4$" x 49 1/$_4$")

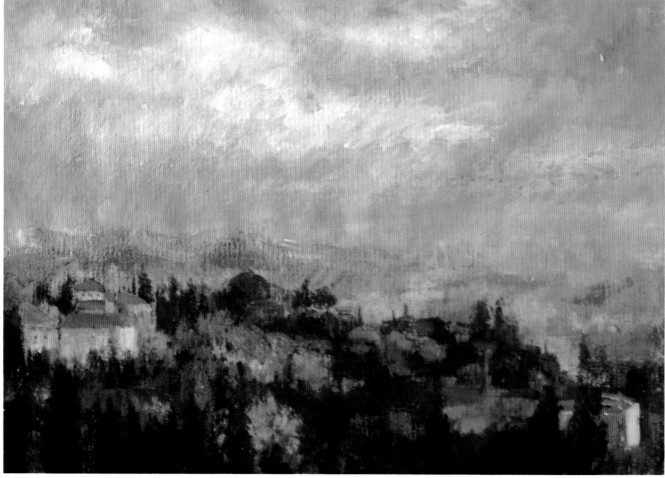

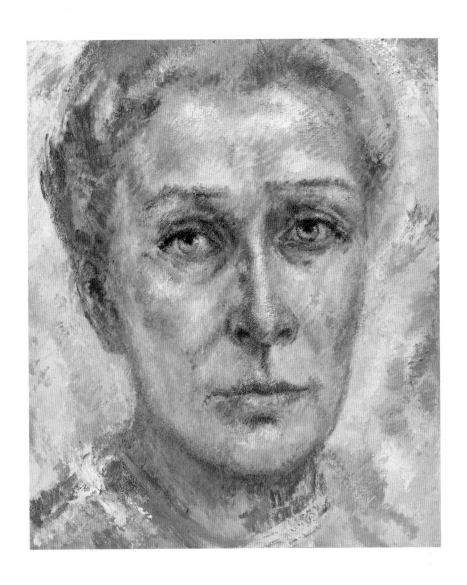

51 (facing page - top)
Casa Salviati & Palazzo dei Pazzi
Florence - signed, 1971
Acrylic on paper
20 x 34 cm (8" x 13 $^3/_8$")

52 (facing page - bottom)
View from San Domenico
Florence, 1971
Acrylic on paper
21 x 30 cm (8 $^1/_4$" x 11 $^7/_8$")

53
Suzanne Danco
Large Head – signed, 1971
Acrylic on masonite
82 x 70 cm (32 $^1/_4$" x 27 $^1/_2$")

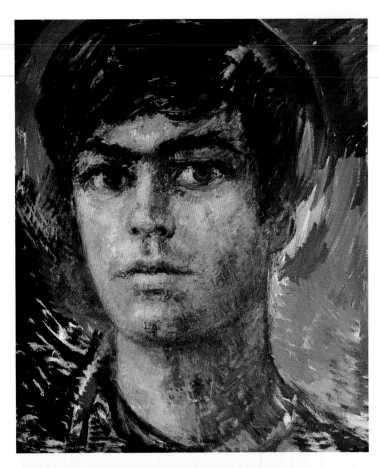

54
Christian Raoul-Duval
Large Head – signed, 1972
Acrylic on masonite
154 x 137 cm (54 $^1/_4$" x 49 $^1/_4$")

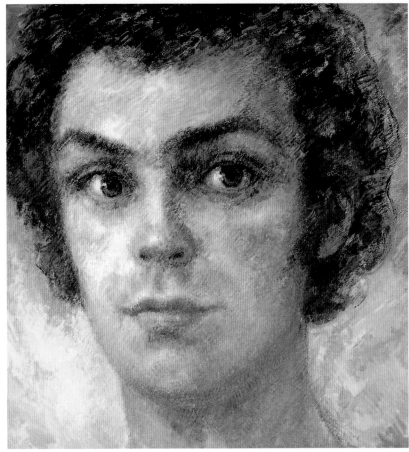

55
Pierre Raoul-Duval
Large Head – signed, 1975
Acrylic on masonite
136 x 127 cm (53 $^1/_2$" x 50")

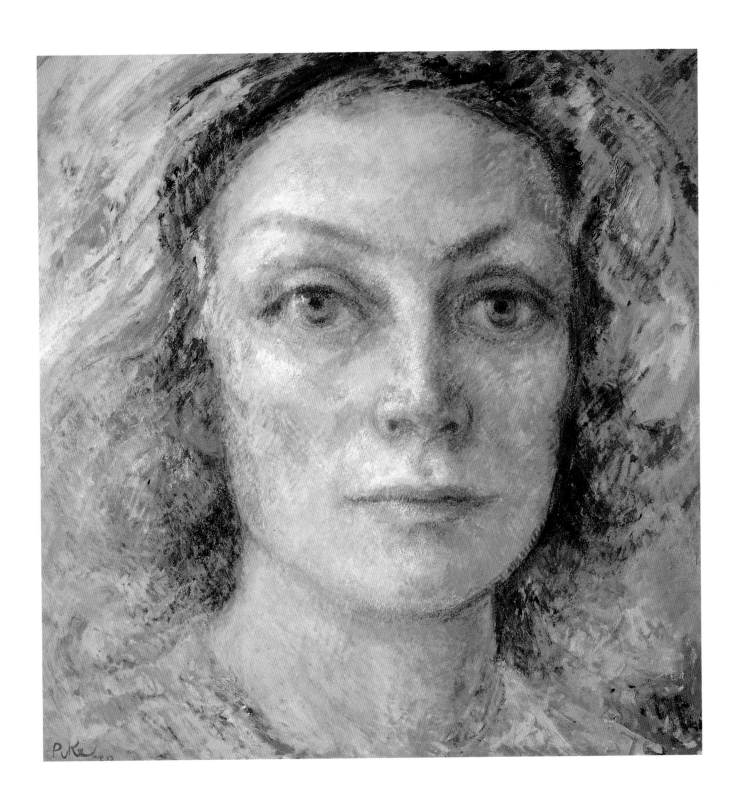

56
Josette Devin
Large Head – signed and dated, 1972
Oil and acrylic on masonite
122 x 119 cm (48" x 46 $^7/_8$")

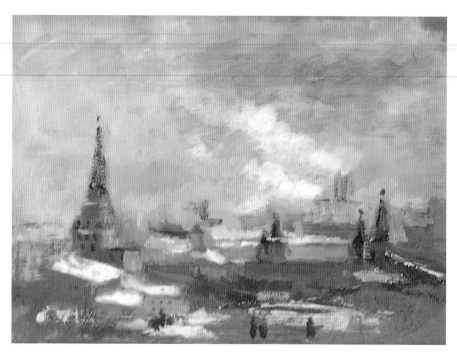

57
View of the Kremlin
Moscow - signed, 1972
Acrylic on paper
19 x 26 cm (7 1/$_2$" x 10 1/$_4$")

58
View from the Seagram Building
New York – signed, 1971
Acrylic on masonite
110 x 100 cm (43 1/$_4$" x 39 3/$_8$")

59
Nadine Cail
Signed, 1971
Acrylic on masonite
60 x 43 cm (23 $^5/_8$" x 17")

In secret she journeys by the naked star
And so high
That no one knows
Where the ring was broken
Of her sleeping years...

Nadine Cail, *La Nuit Quitte ses Racines*
Verdier, 1988

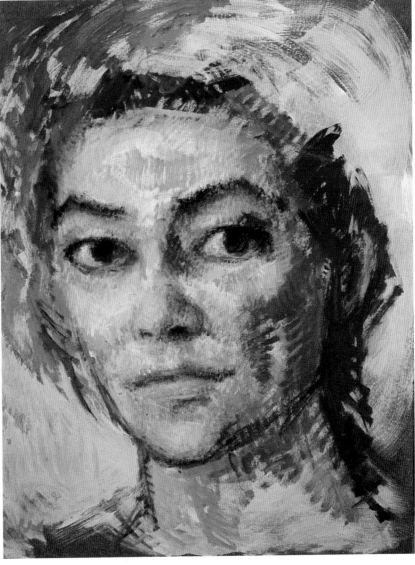

60
Valerie Bettis
Large Head – 1972
Oil and acrylic on canvas
115 x 89 cm (45 $^1/_4$" x 35")

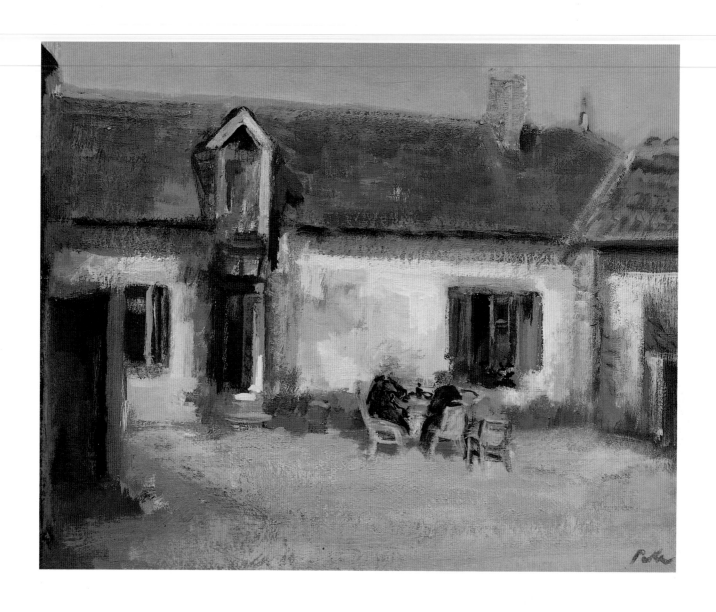

61
La Pacaudière – courtyard scene
Sologne - signed, 1973
Acrylic on cardboard
32 x 39 cm (12 $^5/_8$" x 15 $^3/_8$")

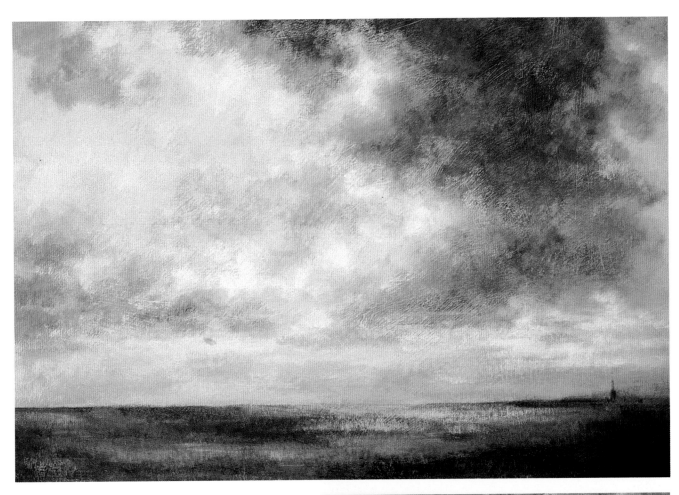

62
French countryside
Signed, 1978
Acrylic on masonite
105 x 124 cm (41 $^3/8$" x 48 $^3/4$")

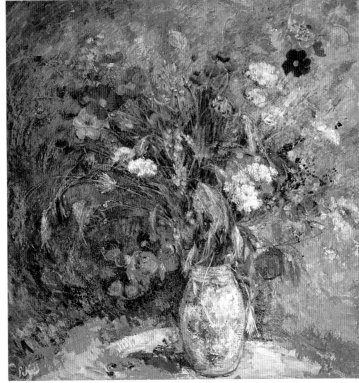

63
Large floral
Signed, 1970
Acrylic on masonite
128 x 125 cm (50 $^3/8$" x 49 $^1/4$")

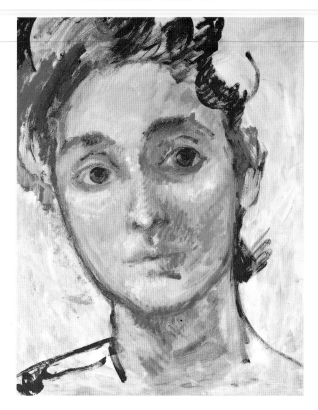 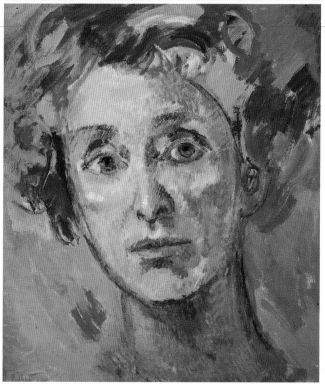

64 (above left)
Dolores Hope – study # 1
Signed, 1973
Acrylic on masonite
120 x 90 cm (47 $^1/_4$" x 35 $^1/_2$")

65 (above right)
Dolores Hope – study # 2
Signed, 1973
Acrylic on masonite
122 x 107cm (48" x 42 $^1/_8$")

66 (facing page – top)
Dolores Hope – study # 3
Signed, 1973
Acrylic on masonite
123 x 122 cm (48 $^3/_8$" x 48")

"About Marion Pike and our long association... The truth and nothing but the truth? She has been an inspiration to all of us. Her love, her joy, her dedication – and by all these gifts her outpouring of such great paintings. Through the years Marion has said many wise and memorable things. None more unforgettable than 'Art is a dialogue, not a monologue.' How true! The lack of just that is most of what is revered today."

Dolores Hope

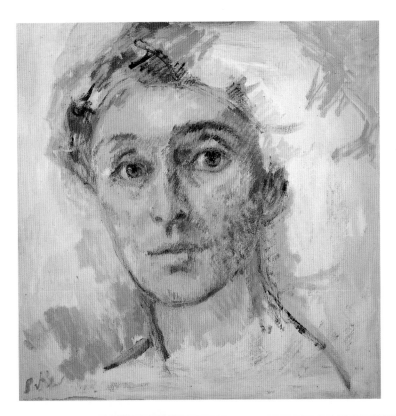

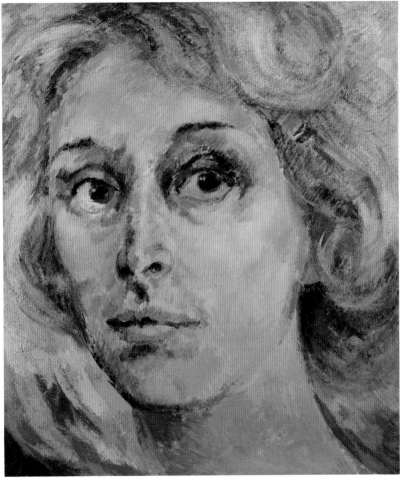

67
Estée Lauder
Large Head – signed, 1974
Acrylic on masonite
142 x 122 cm (55 $^7/8$" x 48")

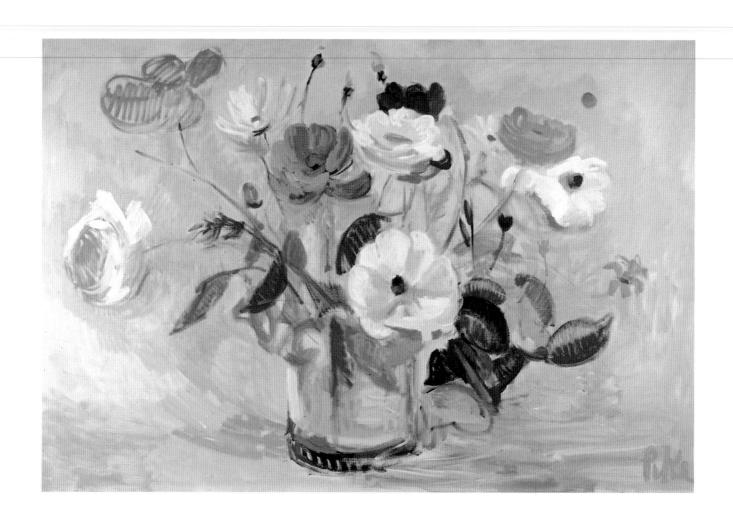

68
Poppies in a glass vase
Signed, 1975
Acrylic on masonite
126 x 194 cm (49 5/8" x 76 3/8")

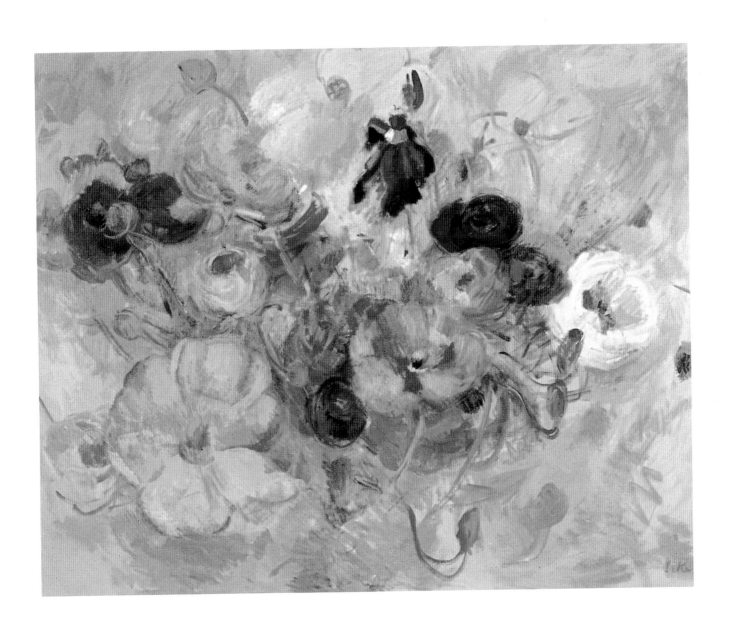

69
Poppies
Signed, 1975
Acrylic on masonite
122 x 151 cm (48" x 59 $^1/_2$")

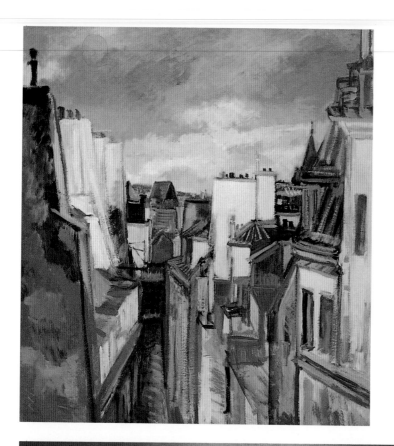

70
Rue de Nevers, Paris
Signed, 1980
Acrylic on masonite
136 x 125 cm (53 $^1/_2$" x 49 $^1/_4$")

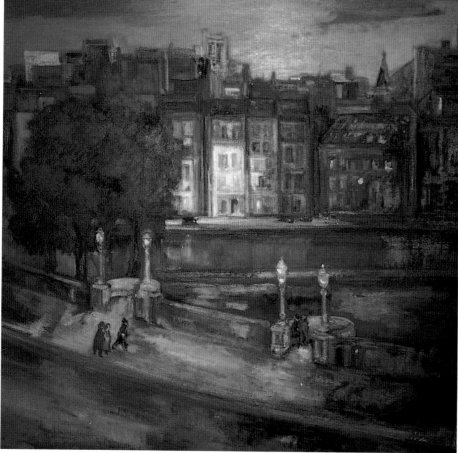

71 (left)
Pont-Neuf at night
Paris - signed, 1982
Acrylic on masonite
115 x 120 cm (45 $^1/_4$" x 47 $^1/_4$")

72 (facing page)
Pont-Neuf, Paris
Signed, 1974
Acrylic on masonite
97 x 76 cm (38 $^1/_4$" x 29 $^7/_8$")

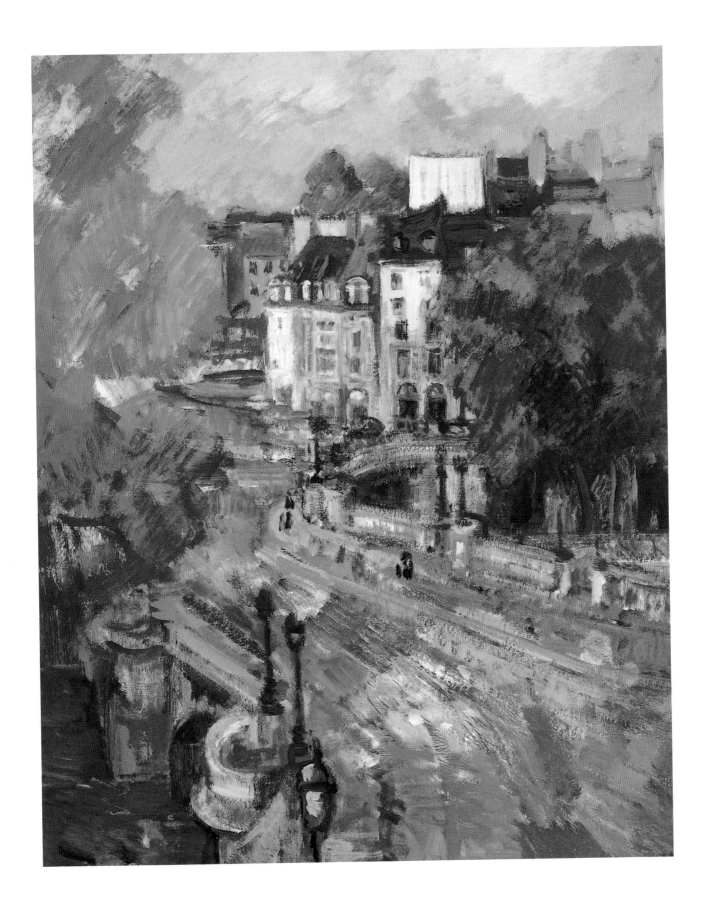

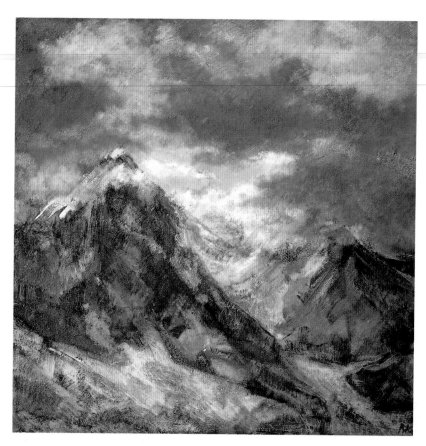

73
Mont-Blanc, France
Signed, 1975
Acrylic on masonite
120 x 120 cm (47 $^1/_4$" x 47 $^1/_4$")

74
Corsica, France
Signed , 1976
Acrylic on masonite
100 x 124 cm (39 $^3/_8$" x 48 $^3/_4$")

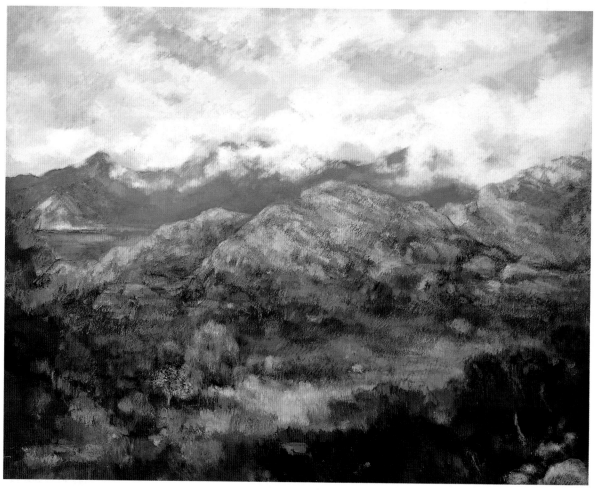

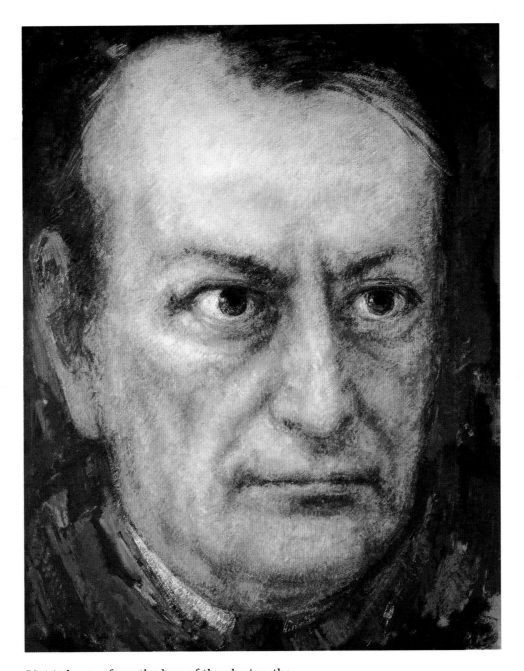

"Art is born... from the lure of the elusive, the inapprehensible... from a desire to wrest forms from the real world to which man is subject and to make them enter into a world of which he is the ruler. The artist knows that his domination is at best precarious, that its progress will be limited, yet he is conscious – passionately at first – of embarking on a vast adventure... Whatever are the gifts revealed in his first attempts and whatever form his apprenticeship may take, he knows that he is starting a journey towards an unknown land, that this first stage of it is of no importance, and that he is *bound to get somewhere*."

André Malraux, *The Voices of Silence*
(translation by Stuart Gilbert)

75
André Malraux
Large Head – signed, 1976
Acrylic on masonite
158 x 124 cm (62 $^1/4$" x 48 $^3/4$")

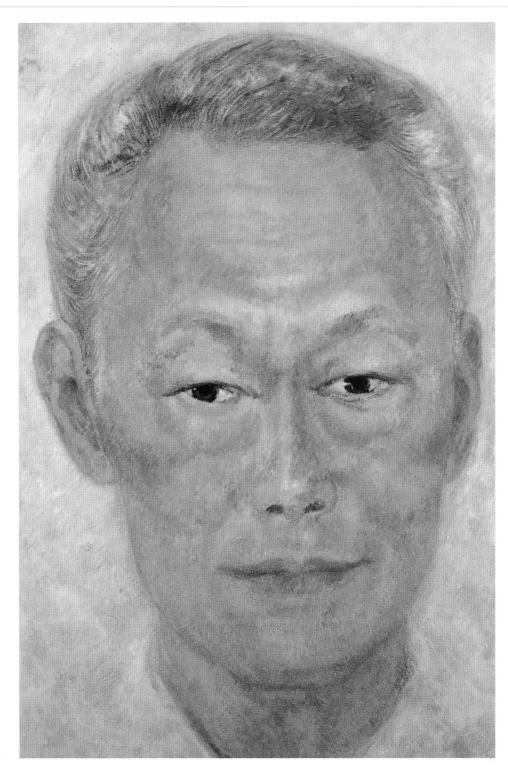

76
Prime Minister Lee Kwan Yew
Large Head – signed, Singapore 1981
Acrylic on masonite
182 x 121 cm (71 $^5/_8$" x 47 $^5/_8$")

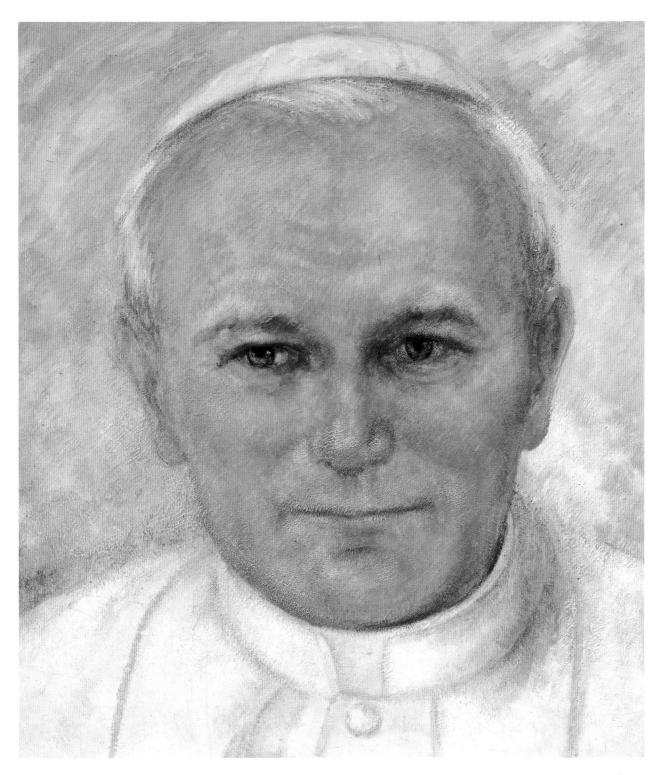

77
Pope John Paul II
Large Head – 1983
Acrylic on masonite
137 x 125 cm (54" x 49")

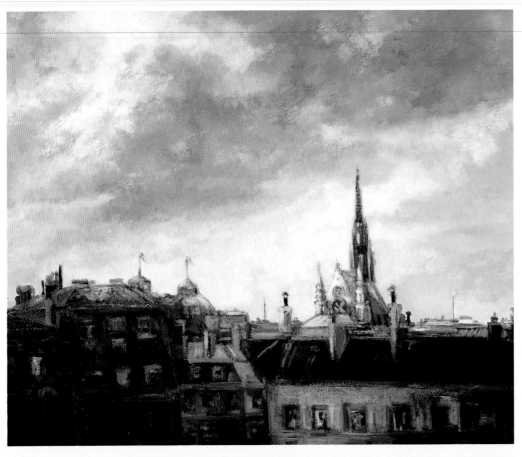

78
Sainte-Chapelle
Paris - signed, 1981
Acrylic on masonite
63 x 76 cm (48 ³/4" x 30")

79
Notre-Dame at night
Paris - signed, 1981
Acrylic on paper
78 x 127 cm (30 ³/4" x 50")

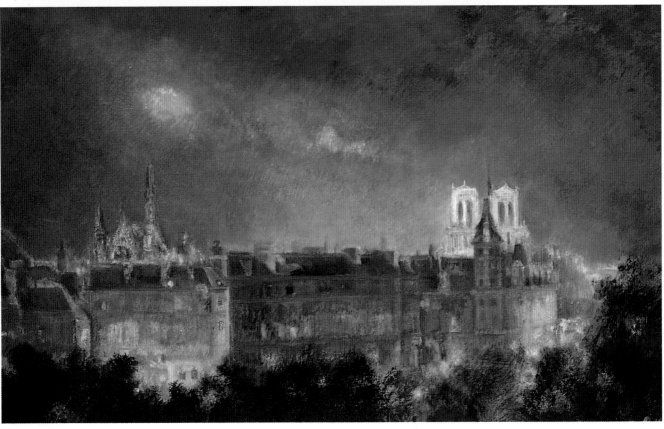

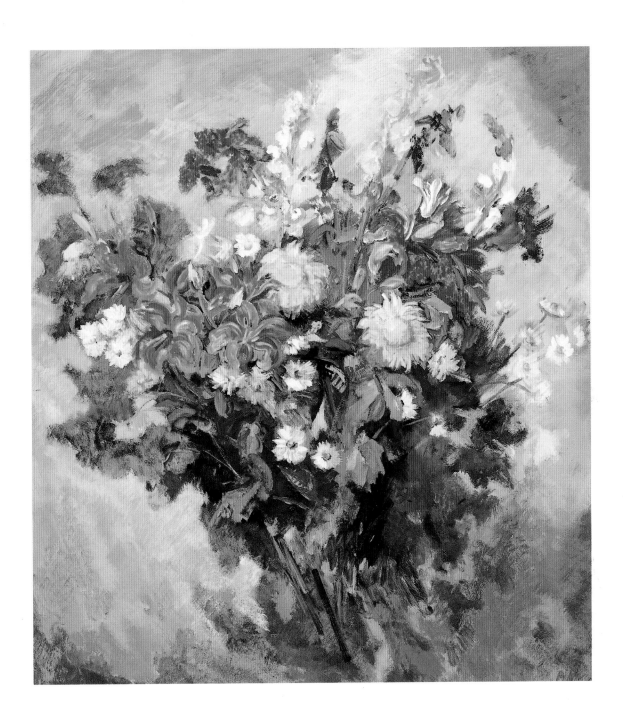

80
Large floral
Signed, 1982
Acrylic on masonite
137 x 125 cm (54" x 49 $^{1}/4$")

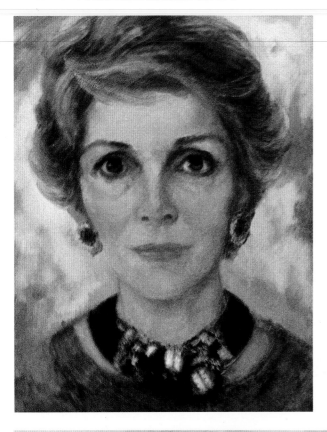

81 (above left)
Nancy Reagan
Large Head – signed, 1983
Acrylic on masonite
120 x 90 cm (47 $^1/_4$" x 35 $^1/_2$")

82 (above right)
Paul Desmarais
Large Head – signed, 1982
Acrylic on masonite
120 x 99 cm (47 $^1/_4$" x 39")

83
Faye Spanos
Large Head – signed, 1983
Acrylic on masonite
122 x 102 cm (48" x 40 $^1/_8$")

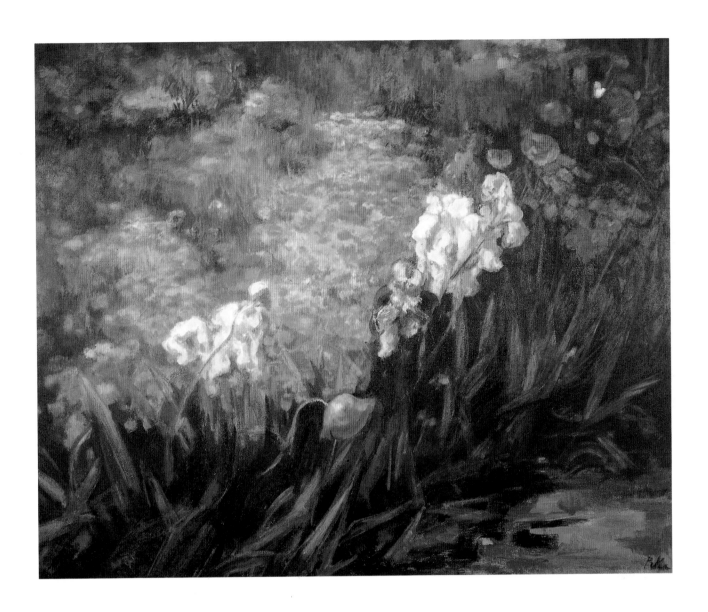

"I always admired in Marion Pike her joyfulness, her prompt intelligence, the determination she puts in her work, her shining talent. She is a great portraitist, and her *figuratisme* is most original."

Gerald Van der Kemp
Curator of the Monet Foundation, Giverny

84
Flowerbed at Giverny
France - signed, 1985
Acrylic and oil on canvas
121 x 151 cm (47 5/$_8$" x 59 1/$_2$")

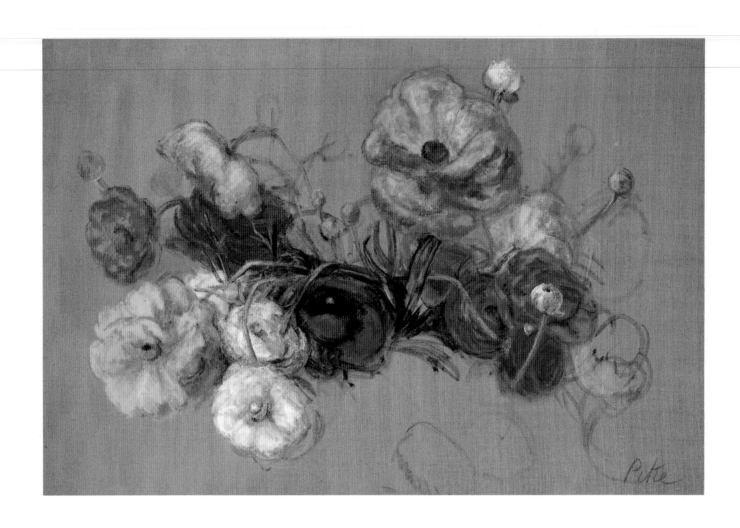

85
Ranuncules
Signed, 1980
Acrylic on canvas
128 x 192 cm (50 $^1/2$" x 75 $^1/2$")

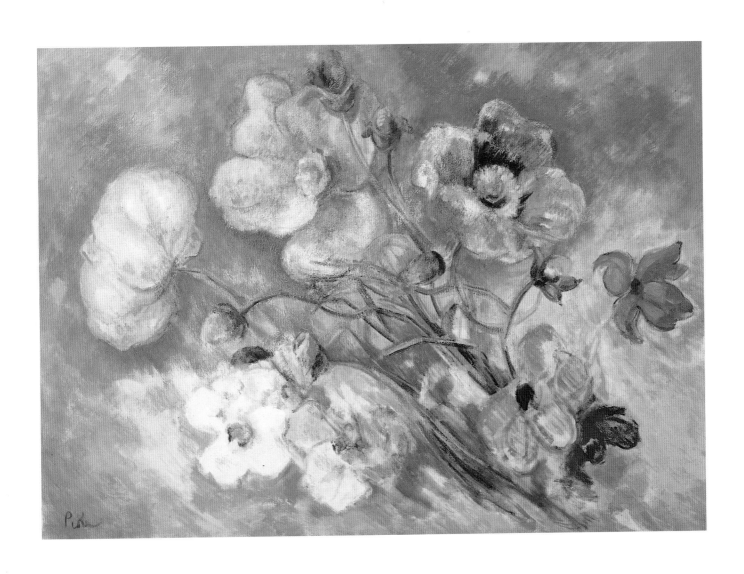

86
Large Poppies
Signed, 1982
Acrylic on canvas
144 x 202 cm (56 3/4" x 79 1/2")

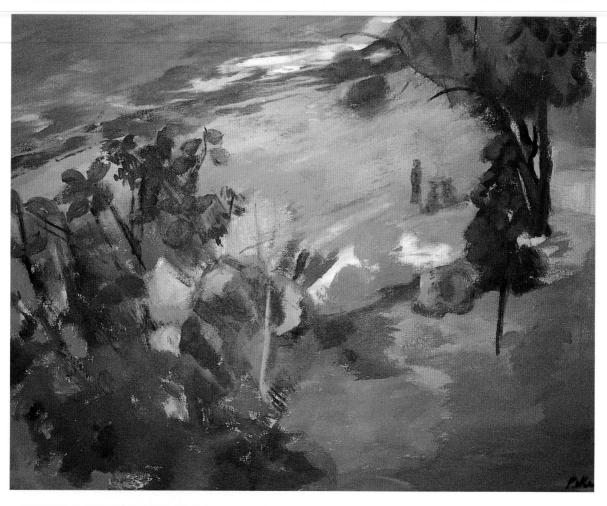

87
Lake Atitlan – lakeshore scene
Guatemala - signed, 1986
Acrylic on canvas
72 x 92 cm (28 $^3/_8$" x 36 $^1/_4$")

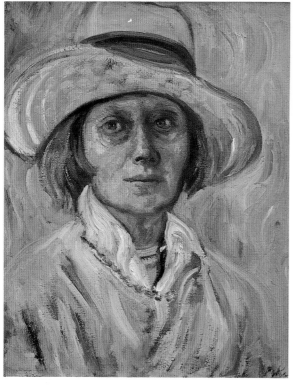

88
Self-portrait
Guatemala - signed, 1988
Oil on canvas
50 x 39 cm (19 $^3/_4$" x 15 $^3/_8$")

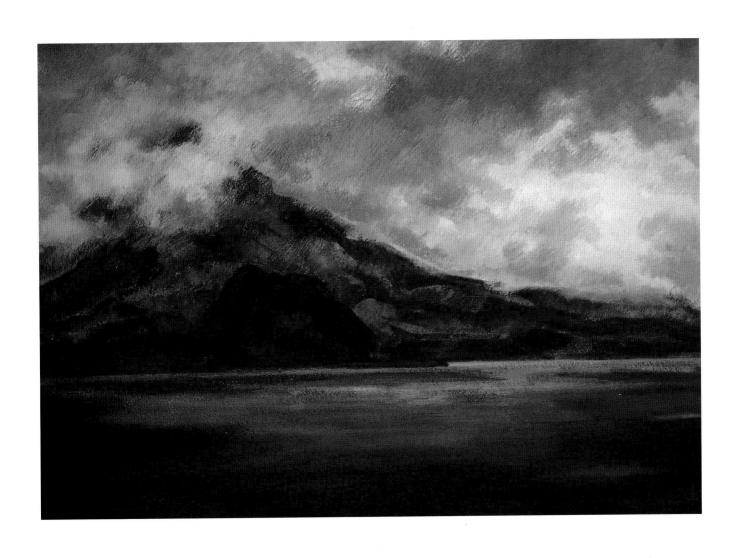

89
Lake Atitlan in the night
Guatemala - signed, 1988
Acrylic on masonite
100 x 135 cm (39 $^3/_8$" x 53")

107

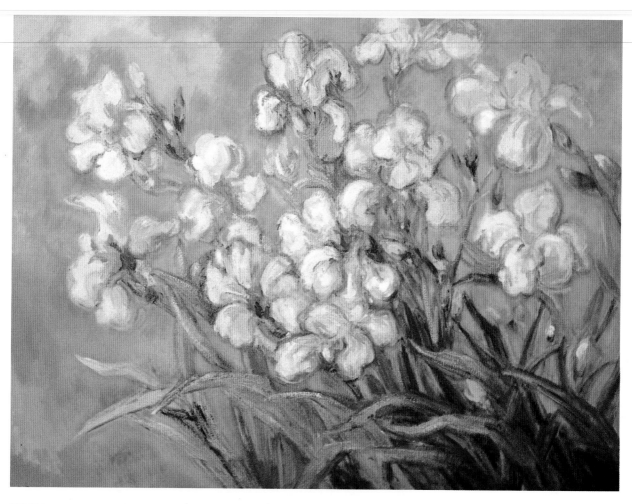

90
Iris
Signed, 1981
Oil on canvas
88 x 104 cm (34 $^5/_8$" x 41")

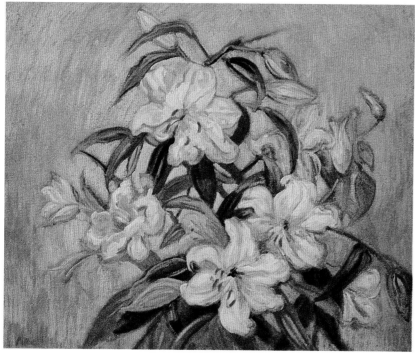

91
Lilies
Signed, 1988
Oil on canvas
81 x 100 cm (32 $^7/_8$" x 39 $^3/_8$")

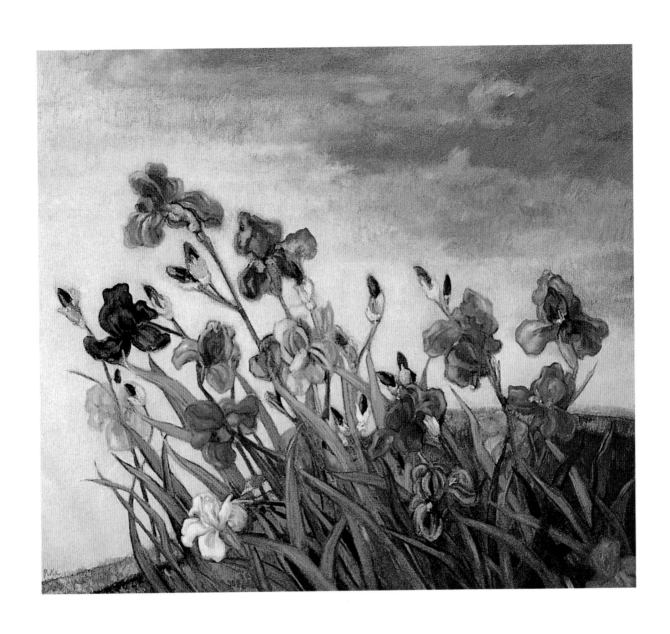

92
Purple iris
Signed, 1989
Oil on canvas
122 x 136 cm (48" x 53 $^1/_2$")

93
Geraldine Halle
Large Head – signed, 1989
Acrylic on masonite
122 x 115 cm (48" x 45 $^1/_2$")

94
Astrid Rottman
Large Head – signed, 1989
Acrylic on masonite
122 x 117 cm (48" x 46")

95
Pascaline
Large Head – signed, 1989
Acrylic on masonite
120 x 100 cm (47 $^1/_4$" x 39 $^3/_8$")

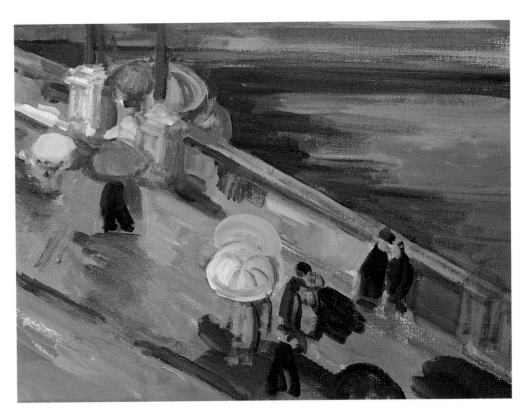

96
Pont-Neuf in the rain
Signed, 1989
Acrylic on canvas
46 x 61 cm (18" x 24")

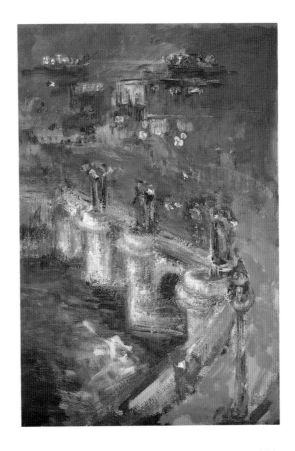

97
Pont-Neuf at night
Signed, 1986
Acrylic on paper
58 x 44 cm (22 $^3/_4$" x 17 $^3/_8$")

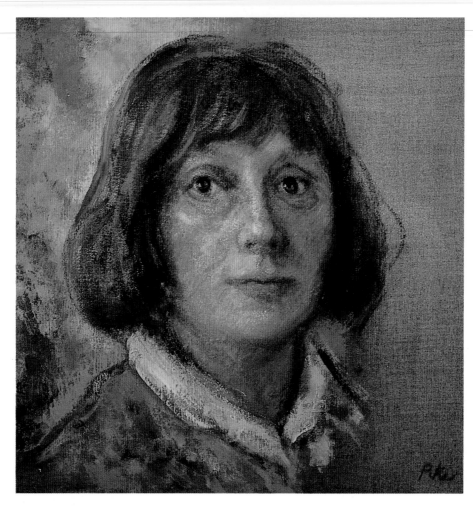

"Beauty makes me believe."
Marion Pike

98
Self-portrait
Signed, 1982
Oil on canvas
41 x 41 cm (16 $^1/_8$" x 16 $^1/_8$")

PEOPLE ARE BACK

by
Frederick S. Wight

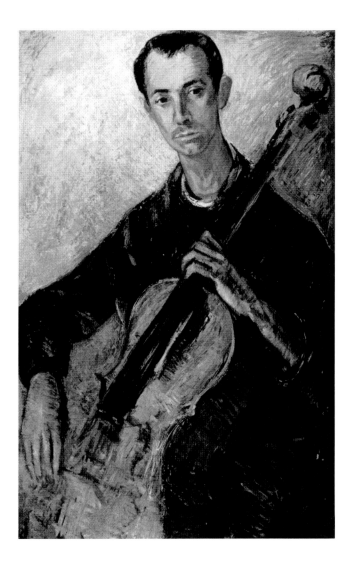

Marion Pike, *Portrait of Edgar Lustgarten*, 1954

Marion Pike is a painter of people. It is odd that this is something to be accounted for, but in modern art people have been out of town for half a century. A world of abstract relationships took over. Painters became architects and physicists. They responded to the great changes, they were building, organizing, rebuilding, symbolizing. And perhaps all this is a kind of preparation, getting ready for people again, for a new understanding of people, seeing them not just from the outside but in all their implications, right through.

It has been difficult, until just now, for a painter of people. He (or she) seemed to be left over from the days when painting people was a trade when vanity was a commodity and painting it was a pretense.

There is no pretense in these paintings. They are of people seen and understood because they are liked. Artists paint what they like most. For a long time now it has been ideas. But ideas are *for* something and people are an end in themselves. Very few really believe this. If you think that people - individuals - are valuable you must feel the fact that they are temporary - mortal, and just for that reason have even been thought to be invaluable and immortal. At all events people change continually. There is a person trapped in their changing physical circumstances, only able to be rescued through artistry and through love.

There have always been images of people, and the artist who made these has been working intensively for the last five years, working years before that. She has studied with Marian Hartwell in San Francisco, with Dorothy Royer in Los Angeles. But mostly she has studied with herself, because she has wanted to do something simple, and do it well.

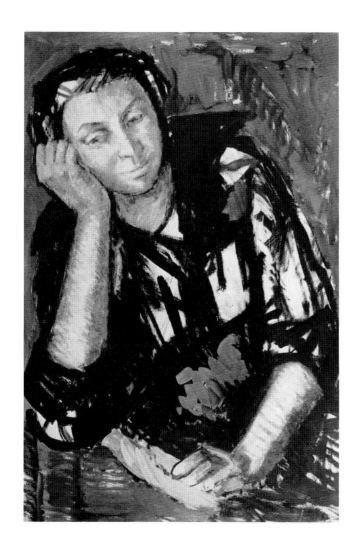

Marion Pike, *Peggy*, 1955

Marion Pike has made her own incursion into the abstract - or perhaps the generalized is a better word. She has painted symbolic figures whose juxtaposition describes a relationship; or she has painted monumental heroic-sized heads (some of her best things) which are more than personalities - they sum up kinds of temperaments, they are archetypes. Marion Pike is deeply responsive to music and perhaps she gets from this the feeling of body, of organization and warmth. But musicians like what is abstract - theirs is *the* abstract art, and perhaps from here comes the artist's feeling for two figures that stand like notes in relation to each other.

You can see that her work is immediate, skilled, and deeply felt. A personality comes onto canvas for her as one person moves spontaneously toward another. You can see that this is managed technically - expressed in paint.

The best thing about these paintings is that the choice of subjects seems felt and justified, and the work seems felt and justified as paint happily managed, and the two things have been made to square and harmonize. The paintings mean just what they say: people can be captured, time can be recaptured, and this is a matter of artistry. The paintings say that people deserve the most that can be given, and this is a rare statement to hear.

Frederick S. Wight

Preface to the catalog of Marion Pike 's exhibition at the Palace of the Legion of Honor, in San Francisco. October 1955.

MARION PIKE – A TRIBUTE

by

Josette Devin

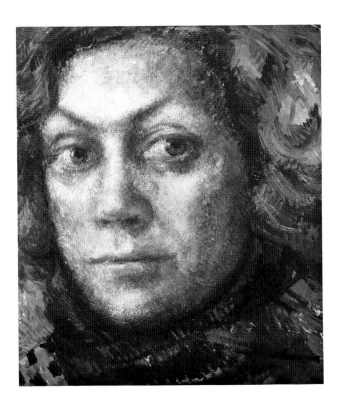

Marion Pike – *Josette Devin*, Paris, 1966

Once Marion Pike told me, " I know why, when I wake up, I am always full of joy: it's because I hope I'll do something beautiful." Here is the secret of Marion's legendary *joie de vivre* : every morning she has an appointment with an unknown painting which expects life and beauty from her.

During the nearly thirty years that she has lived in Paris within my family for a part of the year, I have had the immense privilege to witness the daily encounter between the artist and her art. I learned the rituals, I attended the fights, the victories and the failures. Watching this great painter at work, I have realized that, for her, work is a *raison d'être*: her passion, her obsession, her happiness, her despair.

In Paris, the rituals are simple: every morning after breakfast, Marion enters her studio, a spacious room with large windows. Outside in the limpid northern light, the Seine flows under the Pont-Neuf, watched over by a three-century old equestrian statue of Henri IV. On the right is the Cité, and the towers of Notre-Dame in the distance. On the left is the garden of the Vert-Galant, where a willow displays the changing colors of the seasons.

Inside, in impeccable order, are stacks of canvases and masonite boards, easels, tubes of paint aligned on rolling tables, forests of brushes planted in large copper cauldrons. If even one brush is missing, Marion is immediately aware of it.

The working ambiance could be summarized with a quotation of Li Jih Hua, a Chinese painter from the Ming Era (Marion copied it on an old calendar of the Metropolitan Museum), "Putting paint on paper is no small matter. There should be nothing mundane in the artist's mind before he can bring the wonderful and the unexpected with his brush, such as mist,

clouds, and beauty which naturally correspond to the spirit of growth in heaven and earth."

And certainly there is nothing mundane on the mind of Marion Pike, who refuses all that relates to the trendy or the anecdotal, for whom art is a vocation and the artist a mediator serving a cause that cannot be abandoned. Says Marion, "What I want is to try to recreate what I feel in front of a face, a flower, a landscape. Brushes, canvases and paint are just tools to express this emotion."

Speaking of tools, she knows hers intimately. Through the years, she has explored and mastered most techniques and materials of her art: watercolor, oil, acrylic, pastel, pencil, charcoal... canvas, masonite, and all kinds of paper including non-woven.

She probably was among the very first artists to use acrylic paint, thanks to a fortuitous occurence: her brother-in-law was a paint manufacturer, and one day she asked him for a few cans... In one period, sand and powdered marble also made their appearance on masonite, and it took heroic efforts to painstakingly sand the surface when the layers became too thick. Thus was the studio of a painter transformed into that of a carpenter or marble-worker.

Marion never stops working, and what does not relate to her work is for her a waste of time. When she was painting Chanel and the famous large scene "Chanel working on her collection", Coco offered to make two more *tailleurs* for her. To Chanel's surprise, Marion refused, alleging that she had no time for the fittings.

In Paris, when she leaves her easel, it is to go to the museums, the galleries, or to walk in the quarter, recording in her mind's eye the movements of the clouds, the reflections of the river, the curves of the bridges, the laughter of children. At a restaurant, she does not stop making rapid sketches of people sitting on banquettes, or waiters carrying their round trays, and I can't count the times I saved a bill from Lipp[1], because of a drawing in the corner showing a table laden with bottles, a profile under a lock of hair, or sometimes just a solitary eye under its eyebrow!

Over the years, I have witnessed the making of many of Marion's paintings, and in particular my portraits, my children's and grandchildren's. Something always astonishes me: her pleasure in painting, her enthusiasm in attacking a new canvas, with an appetite undoubtedly inherited from her ancestors, the great American pioneers.

All those who sat for her experienced the same surprise in seeing a face appear so quickly in the famous large oval which starts all of Marion's "Big Heads". From the very beginning, after only a few brush strokes, there is a likeness, which is not a photographic likeness but, rather, an emanation, like a *parfum d'être* where the model already recognizes himself. Then, this surface is destroyed, reworked, and built again in successive layers; it is a furious and meticulous work that lasts whatever it takes, days or months, during which Marion goes through phases of hope and despair. At last comes the day when, with a final stroke, suddenly the portrait is finished.

Among the many faces of the model, Marion instinctively selects the one which best expresses the deepest identity. Going against a trend in contemporary painting, she never distorts a face to expose what may be ugly or mean. It is not that she ignores it, or doesn't see it; but out of the ambiguous mix that is the individual, she always prefers the luminous side to the dark, because she believes in human kindness. And her portraits convey a strange and nostalgic beauty, for they reveal what is deeply buried, what sometimes is never achieved during a lifetime but exists at the core of most human beings: the longing for an ideal, for goodness, for a *noblesse d'être*.

This explains why the eyes, "mirrors of the soul", are so important. Many times I have seen visitors or friends stand still in front of a portrait, struck by the expression of the eyes. I have a vivid memory of Kenneth Clark's[2] reaction when he visited the studio for the first time. He stared at a "Big Head" representing myself, then he took his glasses out of his pocket, and told Marion with his very personal humor, "It is rare for me to want to put my glasses on

when I visit the studio of an artist, but what you are doing is good!" And then he asked Marion to paint his portrait.

Once, in front of a portrait particularly revealing, I couldn't refrain from saying, "But, Marion, how do you do that?". She answered, "I don't know. I look, I look, and something comes inside of me, then I do...."

The good fairies who blessed Marion when she was born certainly gave her, in addition to her great talent, a sixth sense which allows her to see, beyond mere appearances, a deeper level of reality. It is that which interests her, inspires her, and generates the emotion that makes her paint. Poets, writers and artists have at times used drugs in their attempt to reach this other level. Marion does not need this artifice. It is for her a completely natural act of concentration. When Aldous Huxley told her to try mescaline, she replied she had no need, that it was enough for her to look into the heart of a flower.

Often her friends ask Marion if she ever tires of painting faces, landscapes, flowers. And it is true that I've seen her tirelessly paint the Pont-Neuf, the banks of the Seine, the towers of Notre-Dame, the barn and fields of Sologne, in Barbados the sky and the sea, in Guatemala the volcanos of Lake Atitlan... In his diary, Delacroix suggests an explanation for this unremitting effort, "What makes men of genius are not new ideas; it is that idea, which possesses them, that what has been said has still not been said enough."

That may be why Marion never stops working. She has to paint, and paint again, because she knows that what is really important can only be approached, never totally captured. She accepts her difficult destiny as an artist, which is to pursue, in constant dissatisfaction, an endless quest. It is a fascinating experience to be close to the life of a great artist, because her work is never finished.

André Malraux[3] frequently visited Marion's studio and closely followed the evolution of her work. He particularly admired a certain *blue* in her paintings. He liked to establish relationships, to identify "families" – as he said. For him Marion belonged to several of these families: Rembrandt for the portraits, Delacroix for the passion, the elan of shapes and forms. Once, after having examined at length a "Big Head" of my son Christian, which was about to be exhibited in Torino, Malraux turned back and suddenly faced the painting of a Gloxinia on a red background. It was the first time he had seen a Large Flower by Marion. He stopped in astonishment, then turned to me and exclaimed, "It's unbelievable to do that in the middle of the 20th century! It's a modern Rubens, nearly abstract! Where are we going?"

Since André Malraux passed away, many new pictures have been painted, and we still cannot predict what form this "something beautiful" Marion hopes to paint every morning will take. "Isn't it strange", she once told me, "sometimes I pick a piece of canvas in a corner - it may be a bit dusty -and I don't know what will be on it a month from now!" One thing, however, is certain: whatever the painting, it will allow us to participate in the enchantment of a world where Marion finds meaning and joy.

Josette Devin

1 Lipp is a famous brasserie of Saint-Germain-des-Prés.
2 Sir Kenneth McKenzie Clark, art historian, director of the National Gallery in London.
3 André Malraux, prominent French writer, and Minister of Cultural Affairs in the government of General de Gaulle.

SELECTED THEMES

The enjoyment of a picture is not only in the pleasure it inspires, but in the comprehension of the new order of construction used in its making.

Robert Henri, *The Art Spirit*

We are grateful to all those who have helped locate photographs of the works reproduced. The size or the date are not mentioned whenever the available information appeared either inaccurate or unreliable.
For the reader's convenience, the illustrations are always described in the same order, from top, left to right.

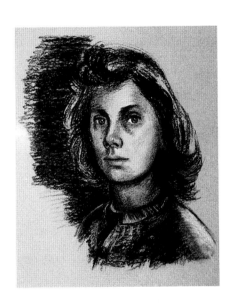

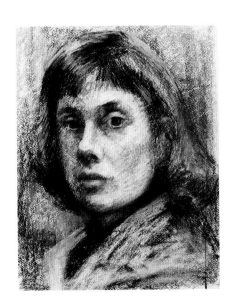

1 – Self-portrait
Pastel, 1940
43 x 35 cm (17 x 13 $^3/_4$")

2 – Self-portrait
Acrylic on canvas, 1957
46 x 32 cm (18 $^1/_8$ x 12 $^5/_8$")

3 – Self-portrait
Oil on canvas, 1961
41 x 33 cm (16 $^1/_8$ x 13")

4 – Self-portrait
Acrylic on paper, 1970
46 x 55 cm (17 $^1/_8$ x 21 $^5/_8$")

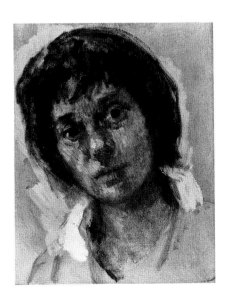

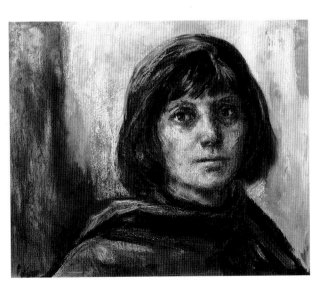

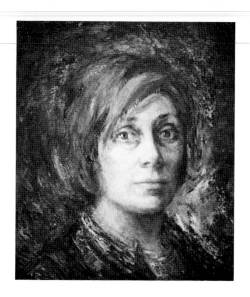

5 – Large self-portrait
 Acrylic on masonite, 1970
 193 x 166 cm (76 x 65 $^3/_8$")

6 – Self-portrait
 Acrylic on masonite, 1970
 73 x 61 cm (28 $^3/_4$ x 24")

7 – Large self-portrait
 Acrylic on masonite, 1974
 132 x 122 cm (52 x 48")

8 – Large self-portrait
 Acrylic on masonite, 1982
 115 x 114 cm (45 $^3/_4$ x 44 $^5/_8$")

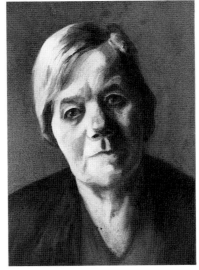

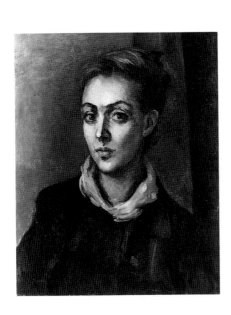

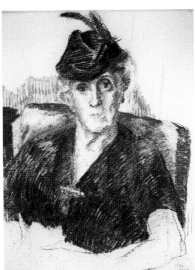

9 – Belle Elston
 Oil on canvas, 1934
 193 x 166 cm (76 x 65 $^3/_8$")

10 – Lena Hoisko
 Oil on canvas, 1938
 73 x 61 cm (28 $^3/_4$ x 24")

11 – Betty Huneke
 Pastel, 1946

12 – Belle Elston
 Pastel, 1947
 63 x 49 cm (24 $^3/_4$ x 19 $^3/_4$")

13 – Antonia Cobos
 Oil on canvas, 1947

14 – Chavela Vargas
 Oil on canvas , 1947

15 – Jean Archibald
 Pastel, 1947
 55 x 29 cm (21 $^5/_8$ x 11 $^3/_8$")

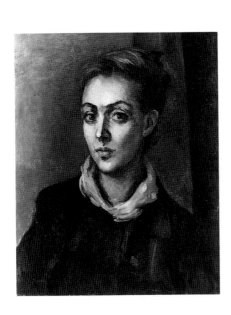

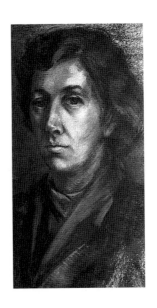

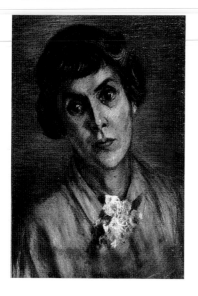

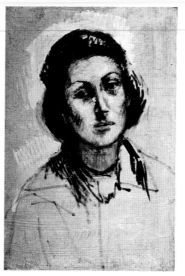

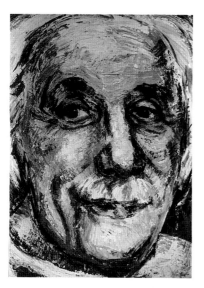

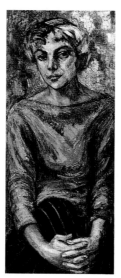

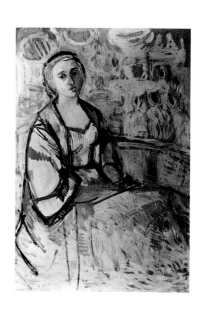

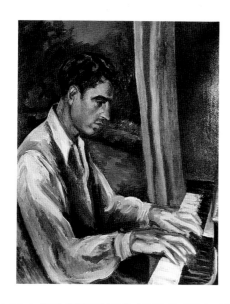

16 – Sally McHose
Pastel, 1948
50 x 34 cm (19 $^3/_4$ x 13 $^3/_8$")

17 – Marion Hill
Acrylic on masonite, circa 1952
76 x 51 cm (30 x 2 $^1/_8$")

18 – Albert Einstein
Acrylic on board, 1948

19 – Valerie Bettis
Acrylic on masonite, 1952

20 - Dolores at the Ball
Sketch on masonite, 1954

21 – Dan Gordon at the piano
Oil on canvas , 1952

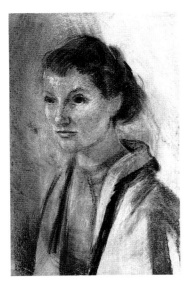 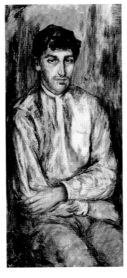 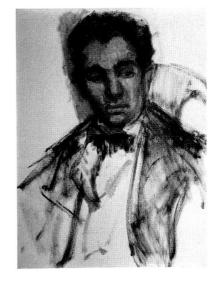

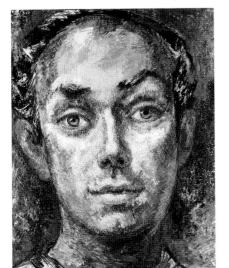 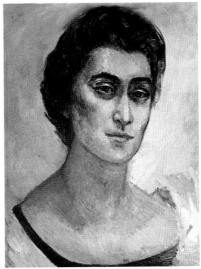

PORTRAITS
1954-1960

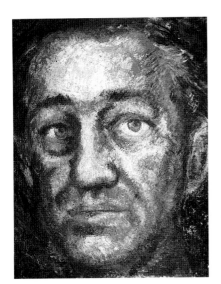 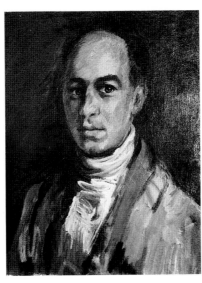

22 – Betsy Church
 Pastel, 1953
 62 x 42 cm (24 $^3/_8$ x 16 $^1/_2$")

23 – Mark
 Acrylic on masonite, 1954
 120 x 53 cm (47 $^1/_4$ x 20 $^7/_8$")

24 – Jerry Zorthian
 Sketch on board, 1955

25 – Anthony Duquette
 Acrylic on masonite, 1956
 152 x 122 cm (60 x 48")

26 – Leila Genser
 Oil on canvas , 1957
 61 x 51 cm (47 x 20 $^1/_8$")

27 - Taft Schreiber
 Acrylic on masonite, 1957
 100 x 80 cm (39 $^3/_8$ x 31 $^1/_2$")

28 – Rafael Soriano
 Oil on canvas , 1956
 51 x 41 cm (20 $^1/_8$ x 16 $^1/_8$")

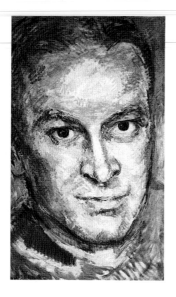

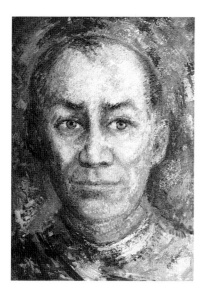

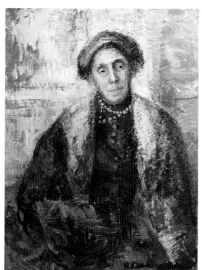

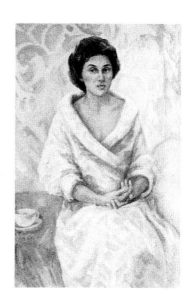

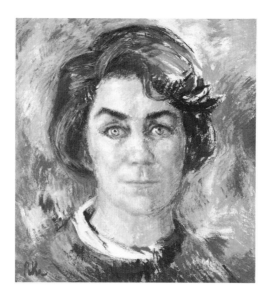

29 – Bob Hope
 Oil on canvas, 1957
 115 x 72 cm (45 $^3/_4$ x 28 $^3/_8$")

30 – David Bright
 Acrylic on masonite, 1958
 147 x 107 cm (57 $^7/_8$ x 42 $^1/_8$")

31 – Madame Paul Valéry
 Acrylic on masonite, 1958
 80 x 62 cm (31 $^1/_2$ x 24 $^3/_8$")

32 – Jane
 Oil on canvas, 1960
 108 x 68 cm (42 $^1/_2$ x 26 $^3/_4$")

33 – Mrs. Thomas Potter Pike
 Acrylic on masonite, 1960
 120 x 114 cm (47 $^1/_4$ x 45")

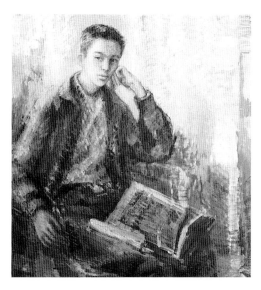

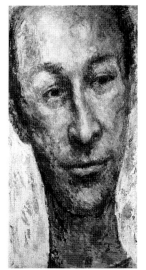

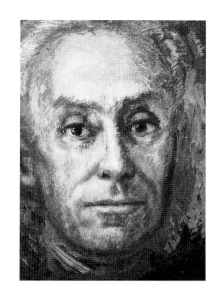

PORTRAITS
1961-1970

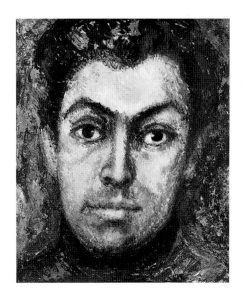

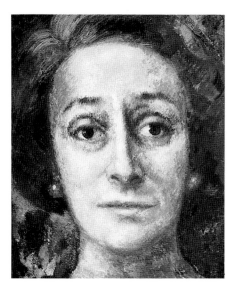

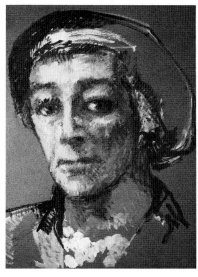

34 – Morgan Adams
 Acrylic on masonite, 1962
 126 x 120 cm (45 $^3/_4$ x 28 $^3/_8$")

35 – Pierre Darbon
 Acrylic on masonite, 1962
 124 x 65 cm (57 $^7/_8$ x 42 $^1/_8$")

36 – George Cukor
 Acrylic on masonite, 1965
 122 x 92 cm (31 $^1/_2$ x 24 $^3/_8$")

37 – Zubin Mehta
 Acrylic on masonite, 1965

38 – Lucille E. Simon
 Acrylic on masonite, 1960
 128 x 100 cm (47 $^1/_4$ x 45")

39 – Louise de Vilmorin
 Oil on canvas, 1965
 138 x 122 cm (42 $^1/_2$ x 26 $^3/_4$")

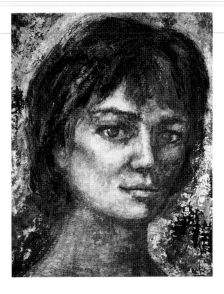 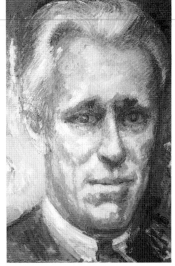 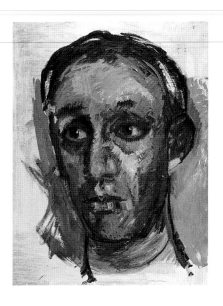

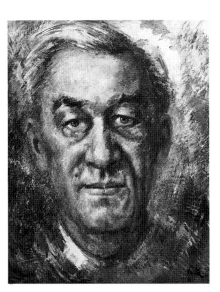 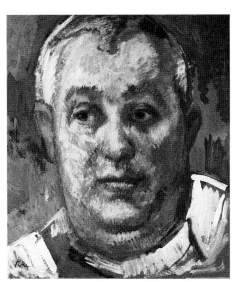

PORTRAITS

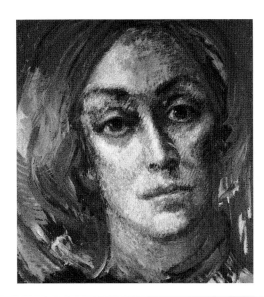

40 – Laurie McBride
 Acrylic on masonite, 1966
 152 x 122 cm (59 $^7/_8$ x 48")

41 – John Walker III
 Acrylic on masonite, 1966

42 – Norton Simon
 Sketch on masonite, 1966
 132 x 102 cm (52 x 40 $^1/_8$")

43 – Dr. Wallace Sterling
 Acrylic on masonite, 1966
 153 x 121 cm (60 $^1/_4$ x 47 $^5/_8$")

44 – Monsieur Garin
 Acrylic on masonite, 1960
 100 x 89 cm (39 $^3/_8$ x 35")

45 – Phyllis de Cuevas
 Acrylic on masonite, 1966
 110 x 110 cm (43 $^1/_4$ x 43 $^1/_4$")

130

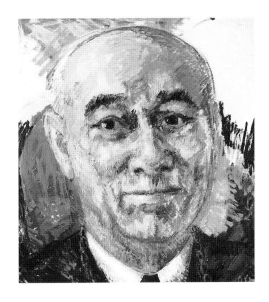

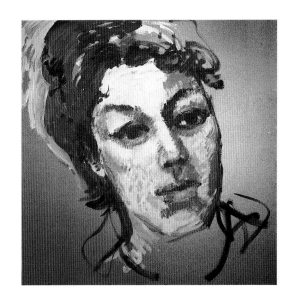

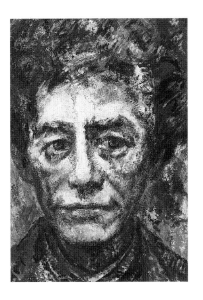

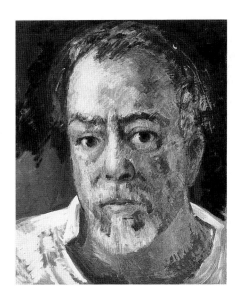

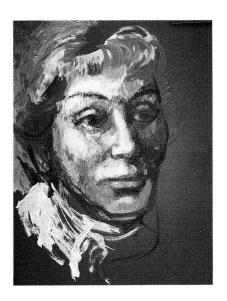

46 – Monsieur Hennocq
 Acrylic on masonite, 1966

47 – Rosalind Russell
 Acrylic on masonite, 1966
 114 x 114 cm (44 $^7/_8$ x 44 $^7/_8$")

48 – Alberto Giacometti
 Acrylic on masonite, 1966
 195 x 114 cm (76 $^3/_4$ x 44 $^7/_8$")

49 – Frank Perls
 Acrylic on masonite, 1967
 149 x 122 cm (58 $^5/_8$ x 48")

50 – Claudette Colbert
 Acrylic on masonite, 1970
 116 x 89 cm (39 $^1/_4$ x 35")

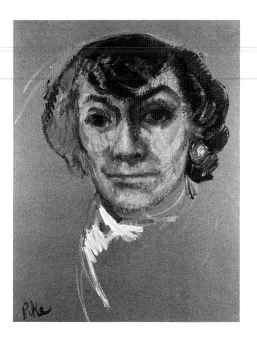

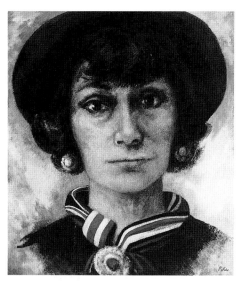

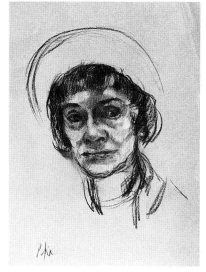

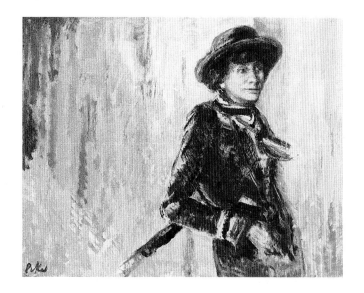

51 – Chanel
Acrylic on masonite, 1968

52 – Chanel
Acrylic on masonite, 1968
137 x 122 cm (54 x 48")

53 – Chanel
Pencil on paper, 1968

54 – Chanel on balcony
Acrylic on board, 1968
80 x 105 cm (31 ¹/₂ x 41 ¹/₄")

JOSETTE

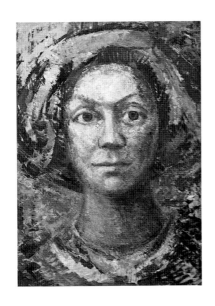

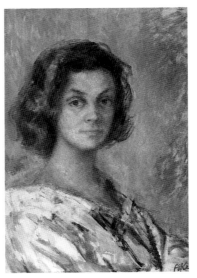

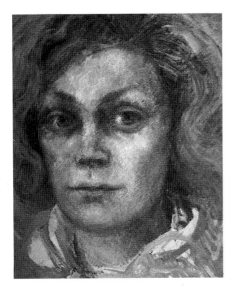

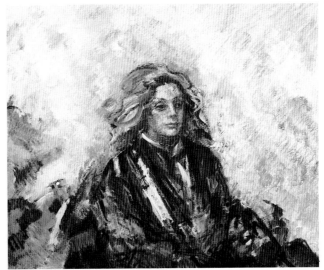

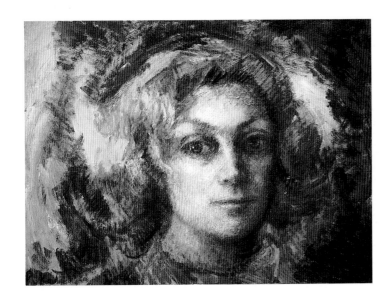

55 – Large head of Josette
 Acrylic on masonite, 1961
 163 x 115 cm (64 1/$_8$ x 45 1/$_4$")

56 – Josette
 Oil on canvas, 1963
 72 x 53 cm (28 3/$_8$ x 20 7/$_8$")

57 – Josette
 Acrylic on masonite, 1974
 125 x 105 cm (49 1/$_4$ x 41 1/$_4$")

58 – Josette in black gown
 Acrylic on masonite, 1971
 112 x 131 cm (44 1/$_8$ x 51 1/$_2$")

59 – Josette
 Acrylic on masonite, 1979
 61 x 81 cm (24 x 32")

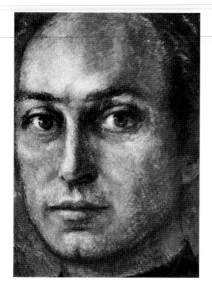 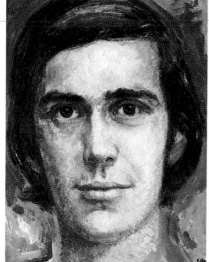 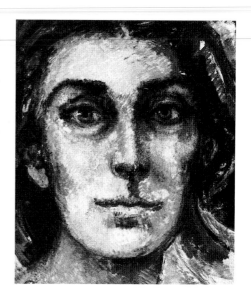

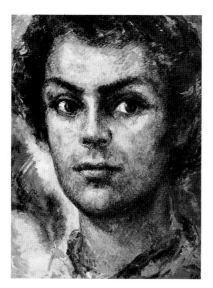 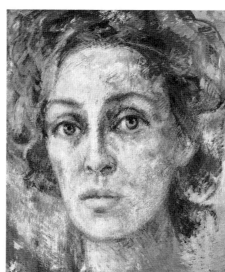

PORTRAITS
1970-1979

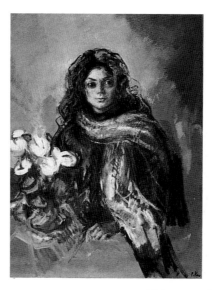

60 – Prince Alexander of Yugoslavia
Acrylic on masonite, 1972
135 x 103 cm (53 $^1/_8$ x 40 $^1/_2$")

61 – Bernard Neveu
Acrylic on masonite, 1972
105 x 85 cm (28 $^3/_8$ x 20 $^7/_8$")

62 – Anne-Marie Loyrette
Acrylic on masonite, 1973

63 – Pierre Raoul-Duval
Acrylic on masonite, 1971
148 x 114 cm (58 $^1/_4$ x 44 $^7/_8$")

64 – Mrs. Patrick Frawley
Acrylic on masonite, 1975

65 – Ariane Raoul-Duval
Acrylic on masonite, 1977
118 x 90 cm (46 $^1/_2$ x 35 $^3/_8$")

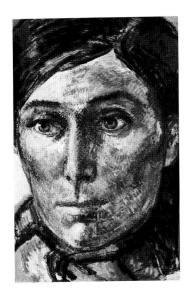

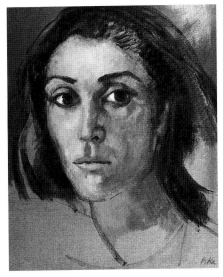

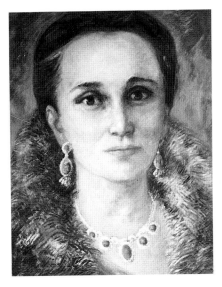

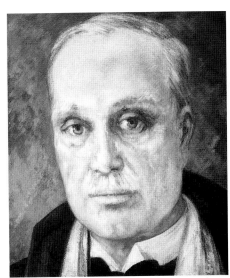

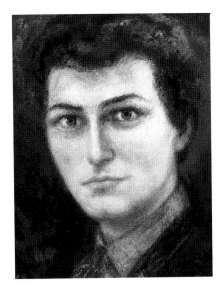

66 – Nadine Cail
 Acrylic on masonite, 1980
 136 x 85 cm (53 $^1/_2$ x 33 $^1/_2$")

67 – Nicole Sarda
 Acrylic on canvas, 1974
 92 x 76 cm (36 $^1/_4$ x 30")

68 – Princesse de Lobkowicz
 Acrylic on masonite, 1982
 119 x 94 cm (46 $^7/_8$ x 37")

69 – Prince de Lobkowicz
 Acrylic on masonite, 1982
 104 x 94 cm (41 x 25 $^1/_4$")

70 – André Desmarais
 Acrylic on masonite, 1982
 159 x 122 cm (62 $^5/_8$ x 48")

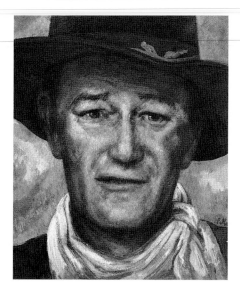

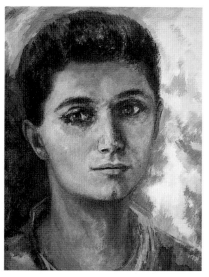

71 – John Wayne
Acrylic on masonite, 1985
122 x 107 cm (48 x 42 $^1/_8$")

72 – Judy del Carril
Acrylic on masonite, 1986
123 x 138 cm (48 $^3/_8$ x 54 $^1/_4$")

73 – Dr. Michèle Le Troquer
Acrylic on masonite, 1986
122 x 80 cm (48 x 31 $^1/_2$")

74 – Princesse Bernadotte
Acrylic on masonite, 1985
90 x 100 cm (35 $^1/_2$ x 39 $^3/_8$")

75 – Valérie Raulin
Acrylic on masonite, 1986
126 x 137 cm (49 $^5/_8$ x 54")

76 – Philippe Sarda
Acrylic on masonite, 1987
125 x 105 cm (49 $^1/_4$ x 41 $^3/_8$")

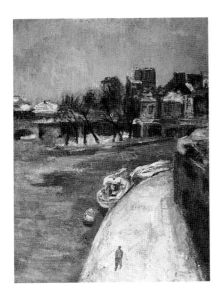

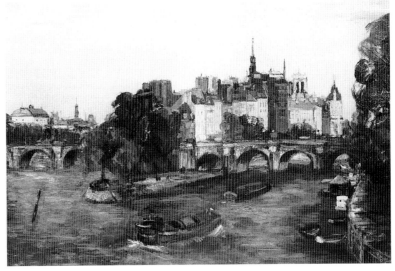

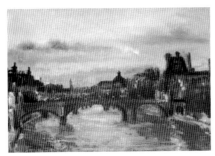

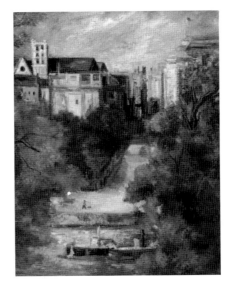

PARIS SCENES
La Seine

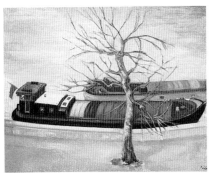

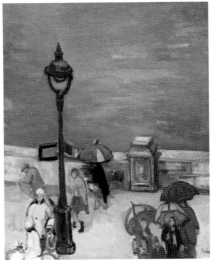

77 – Vert-Galant in winter
Oil on canvas, 1958
73 x 54 cm (28 $^3/_4$ x 21 $^1/_4$")

78 – Vert-Galant and the Cité
Oil on canvas, 1970
125 x 136 cm (49 $^1/_4$ x 53 $^1/_2$")

79 – Sunset on the Seine
Acrylic on masonite, 1966
43 x 60 cm (16 $^7/_8$ x 23 $^5/_8$")

80 – The two barges
Oil on canvas, 1985
78 x 97 cm (30 $^3/_4$ x 38 $^1/_8$")

81 – *La Seine et la Samaritaine*
Acrylic on masonite, 1980
130 x 107 cm (51 $^1/_8$ x 42 $^1/_8$")

82 – *Le kiosque sur le quai*
Oil on canvas, 1984
53 x 64 cm (20 $^7/_8$ x 25 $^1/_4$")

83 – Figures by the river
Oil on canvas, 1984
60 x 49 cm (23 $^5/_8$ x 19 $^1/_4$")

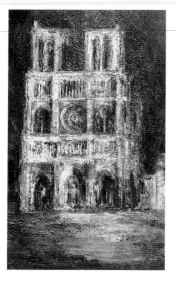

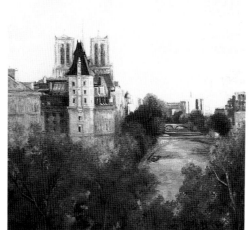

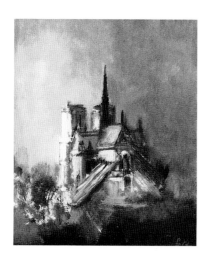

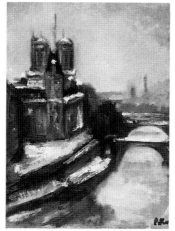

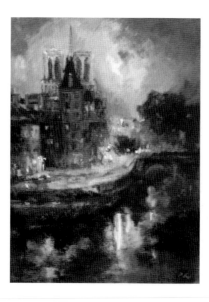

84 – Notre-Dame in the night
 Acrylic on masonite, 1978
 125 x 75 cm (49 $^1/_4$ x 29 $^1/_2$")

85 – *La Cité*
 Oil on canvas, 1983
 137 x 125 cm (53 $^7/_8$ x 49 $^1/_4$")

86 – Apse of Notre-Dame at night
 Acrylic on panel, 1981
 41 x 33 cm (16 $^1/_8$ x 13")

87 – La Cité in winter
 Acrylic on panel, 1985
 35 x 27 cm (13 $^3/_4$ x 10 $^5/_8$")

88 – La Cité in the night
 Acrylic on canvas, 1984
 130 x 97 cm (51 $^1/_8$ x 31 $^1/_8$")

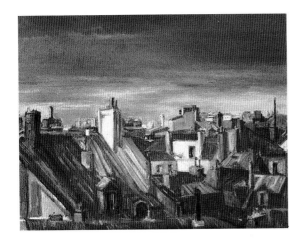

PARIS SCENES
Rooftops
Rue de Nevers

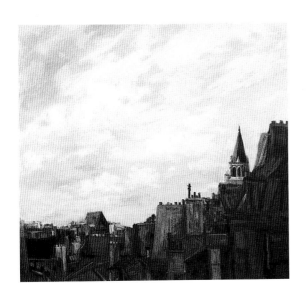

89 – Paris rooftops
 Acrylic on masonite, 1964
 24 x 30 cm (9 $^1/_2$ x 11 $^7/_8$")

90 – Rooftops of Saint-Germain
 Acrylic on masonite, 1982
 124 x 136 cm (48 $^3/_4$ x 53 $^1/_2$")

91 – Rue de Nevers in the sun
 Acrylic on panel, 1981
 70 x 53 cm (27 $^1/_2$ x 20 $^7/_8$")

92 – Rue de Nevers at dusk
 Acrylic on panel, 1981
 73 x 60 cm (28 $^3/_4$ x 23 $^5/_8$")

93 – Rue de Nevers in winter
 Acrylic on canvas, 1975
 79 x 58 cm (31 $^1/_8$ x 22 $^7/_8$")

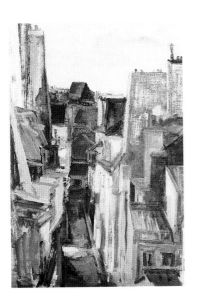

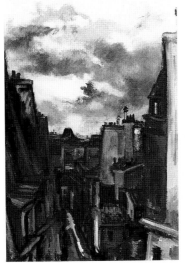

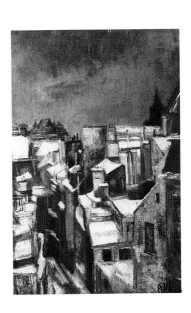

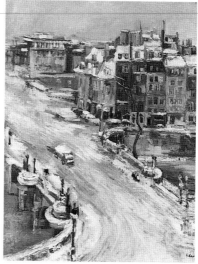

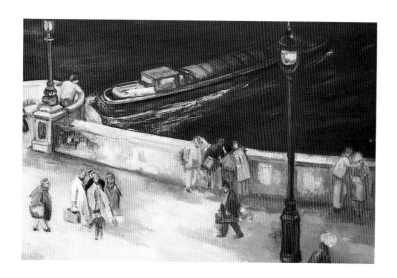

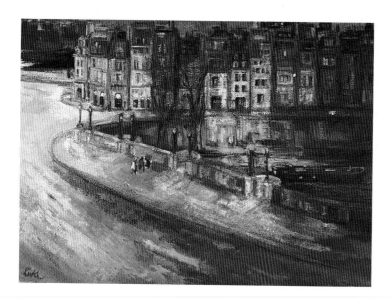

94 – Pont-Neuf
Acrylic on canvas, 1973
125 x 138 cm (49 1/$_4$ x 54 3/$_8$")

95 – Pont-Neuf in winter
Acrylic on masonite, 1975

96 – Figures on the Pont-Neuf
Acrylic on canvas, 1985
65 x 90 cm (25 5/$_8$ x 35 3/$_8$")

97 – Pont-Neuf at night
Acrylic on masonite, 1985
155 x 78 cm (61 x 30 3/$_4$")

98 – Pont-Neuf in the night
Oil on canvas, 1988
97 x 130 cm (38 1/$_8$ x 51 1/$_8$")

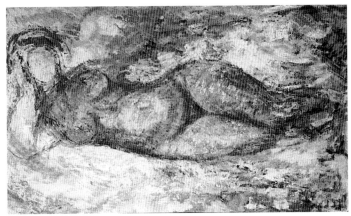

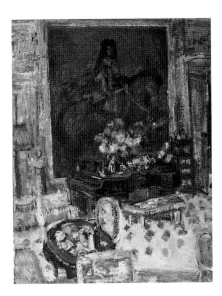

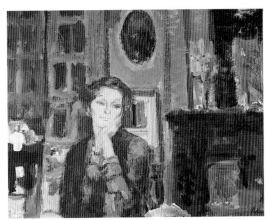

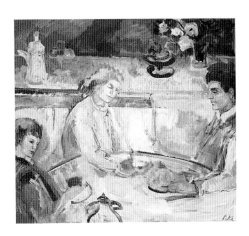

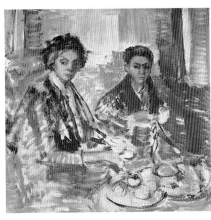

99 – The open window
 Oil on canvas, 1960
 102 x 76 cm (40 $^1/_8$ x 29 $^7/_8$")

100 – Reclining nude
 Acrylic on masonite, 1963

101 – *Le Salon Bleu*, at Verrières
 Acrylic on masonite, 1962
 85 x 64 cm (33 $^1/_2$ x 25 $^1/_4$")

102 – Louise at Verrières
 Acrylic on masonite, 1966
 50 x 79 cm (19 $^3/_4$ x 31 $^1/_8$")

103 – *Le Goûter*
 Acrylic on masonite, 1975
 125 x 137 cm (49 $^1/_4$ x 53 $^7/_8$")

104 – Josette and Pierre
 Acrylic on masonite, 1962

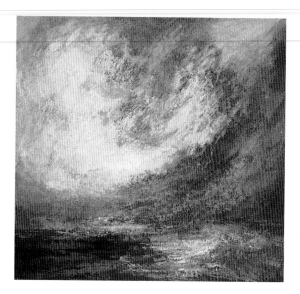

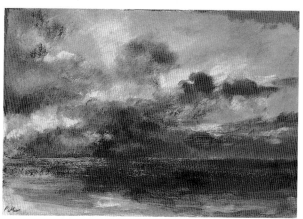

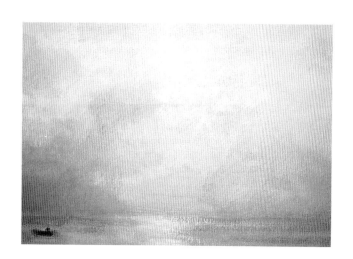

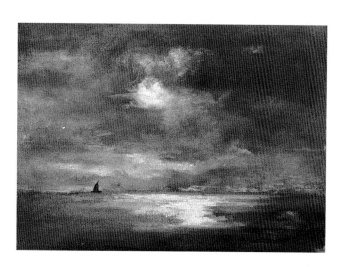

105 – The storm
Acrylic on masonite, 1970
69 x 75 cm (27 $^1/_8$ x 29 $^1/_2$")

106 – Clouds
Acrylic on paper, 1973

107 – Seascape
Acrylic on paper, 1986
24 x 35 cm (9 $^1/_2$ x 13 $^3/_4$")

108 – Claudette's garden
Acrylic on paper, 1976
63 x 47 cm (24 $^3/_4$ x 18 $^1/_2$")

109 – Black sail in the moonlight
Oil on canvas, 1983
42 x 58 cm (16 $^1/_2$ x 22 $^7/_8$")

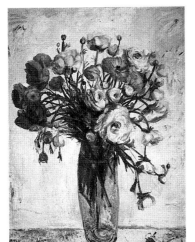
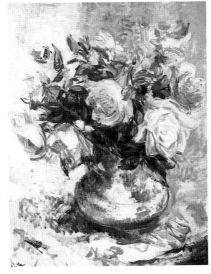
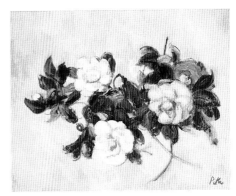

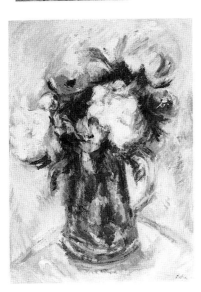
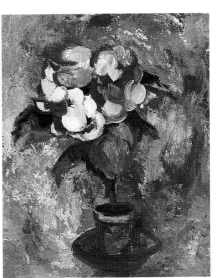

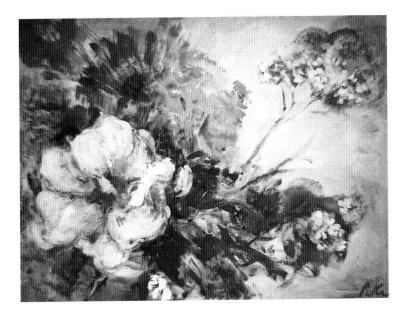

110 – Bouquet in a glass vase
 Acrylic on masonite, 1956

111 – Roses
 Oil on canvas, 1956

112 – Camelia
 Acrylic on panel, 1982

113 – Floral
 Acrylic on masonite, 1962
 72 x 50 cm (28 $^{3}/_{8}$ x 19 $^{3}/_{4}$")

114 – Camelia in pot
 Acrylic on masonite, 1969
 80 x 60 cm (31 $^{1}/_{2}$ x 23 $^{5}/_{8}$")

115 – Large Floral
 Acrylic on masonite, 1983
 95 x 125 (37 $^{3}/_{8}$ x 49 $^{1}/_{4}$")

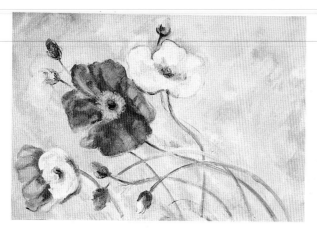

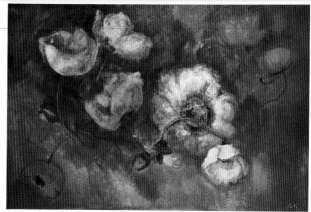

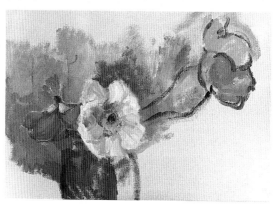

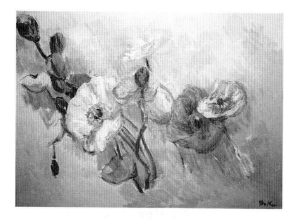

POPPIES

116 – Large Poppies
Acrylic on canvas, 1974
92 x 153 cm (36 $^1/_8$ x 60 $^1/_4$")

117 – Giant Poppies
Acrylic on canvas, 1975
130 x 196 cm (51 $^1/_8$ x 77 $^1/_8$")

118 – Poppies in a glass
Acrylic on canvas, 1974
46 x 61 cm (18 $^1/_8$ x 24")

119 – Poppies
Acrylic on masonite, 1976
34 x 45 cm (13 $^3/_8$ x 17 $^3/_4$")

120 – Large Poppies
Acrylic on masonite, 1975
94 x 122 cm (37 x 48")

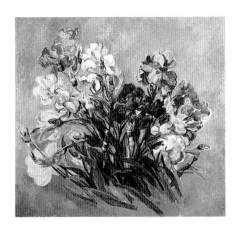 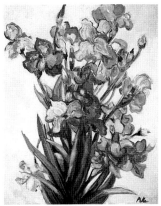

121 – Irises
Oil on canvas, 1982
130 x 133 cm (51 $^1/_4$ x 52 $^3/_8$")

122 – Blue Iris
Oil on canvas, 1986
80 x 64 cm (31 $^1/_2$ x 25 $^1/_4$")

123 – Purple iris
Oil on canvas, 1981
81 x 99 cm (31 $^7/_8$ x 39")

124 – Lilies in a basket
Acrylic on masonite, 1974
120 x 151 cm (47 $^1/_4$ x 59 $^1/_2$")

125 – White lilies
Oil on canvas, 1988
73 x 60 cm (28 $^3/_4$ x 23 $^5/_8$")

126 – Large lilies
Acrylic on canvas, 1986
114 x 146 cm (41 x 57 $^1/_2$")

IRISES

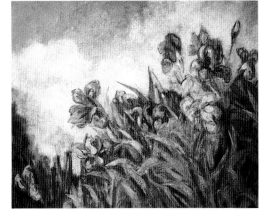

LILIES

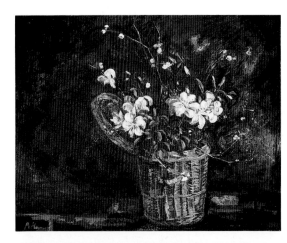

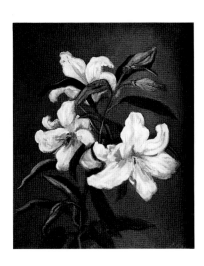 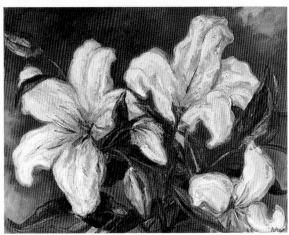

145

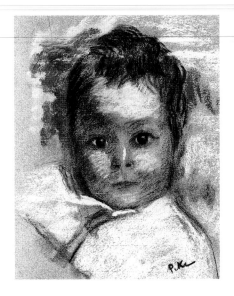 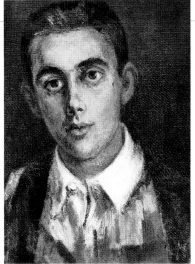 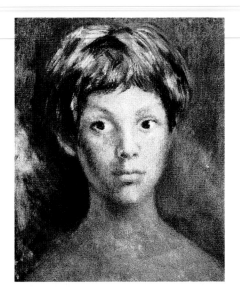

CHILDREN

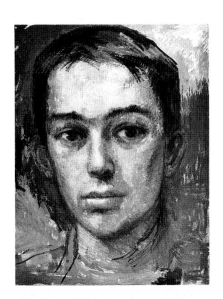

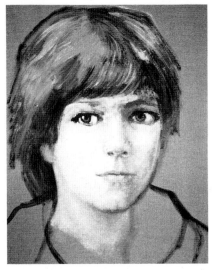 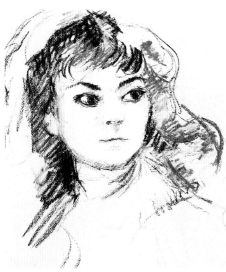

127 – Nora Hope
 Pastel, 1945

128 – Bob Simon
 Oil on canvas, 1958

129 – Pierre Raoul-Duval
 Oil on canvas, 1960

130 – Morgan Adams ("Mo")
 Acrylic on masonite, 1965
 153 x 122 cm (60 $^1/_4$ x 59 $^1/_2$")

131 – Prince Dushan of Yugoslavia
 Acrylic on canvas, 1980
 94 x 75 cm (28 $^3/_4$ x 23 $^5/_8$")

132 – Ariane Raoul-Duval
 Sketch on paper, 1966

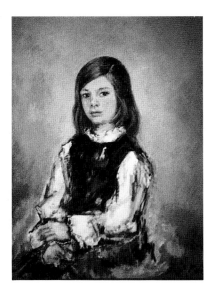
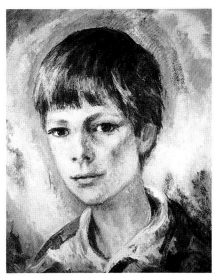

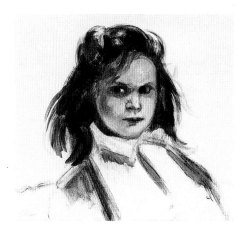

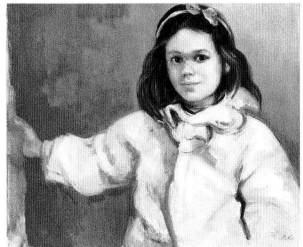

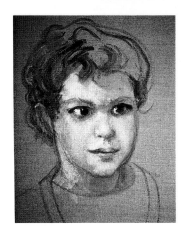
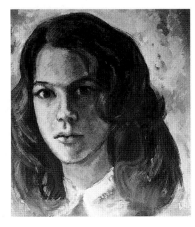

133 – Katherine McBride
 Acrylic on masonite, 1975
 75 x 60 cm (29 1/$_2$ x 23 5/$_8$")

134 – Janice Vest
 Acrylic on masonite, 1975
 92 x 76 cm (36 x 30")

135 – Marie
 Sketch on canvas, 1985
 45 x 55 cm (17 3/$_4$ x 21 5/$_2$")

136 – Marie Raoul-Duval
 Oil on canvas, 1985
 46 x 55 cm (18 1/$_8$ x 21 5/$_8$")

137 – Jean Raoul-Duval
 Acrylic on canvas, 1988
 72 x 60 cm (28 3/$_8$ x 23 5/$_8$")

138 – Sara Hudson
 Acrylic on masonte, 1986
 124 x 104 cm (48 3/$_4$ x 41")

139 – Lake Atitlan – view from the studio
Acrylic on canvas, 1987

140 – Indian girl
Acrylic on masonite, 1940
61 x 46 cm (24 x 18 $^1/_8$")

141 – Lake Atitlan
Oil on canvas, 1987
71 x 106 cm (28 x 41 $^3/_4$")

142 – Lake Atitlan
Oil on canvas, 1987
92 x 102 cm (36 $^1/_8$ x 40 $^1/_8$")

143 – The two bathers
Acrylic on canvas, 1988
71 x 106 cm (28 x 41 $^3/_4$")

APPENDICES

SELECTED BIBLIOGRAPHY

"Hewlett Goes Home, Pi Phi's & AKL's Mourn," *Stanford Daily*, May 8, 1933.

Jarvis Barlow, "Art Matters," *Los Angeles Times*, April 1955.

"Mrs. Marion Pike Wins Art Honor," *Los Angeles Times*, 1955.

"Gathering," *San Francisco Examiner*, September 27, 1955.

Dorothy Walker, "Marion Pike's Art Works on Exhibit," *San Francisco News*, October 15 1955.

"Portraits by Marion Pike," *San Francisco Chronicle*, October 15, 1955.

"Parties Honor Artist Marion Pike," *San Francisco Examiner*, October 15, 1955.

"Gala Preview Party for Artist Marion Pike," *San Francisco News*, October 17 1955.

Princess Pignatelli, "Home Town Acclaims Marion Pike," *Los Angeles Examiner*, October 19, 1955.

"S.F.'s Tribute to Artist," *San Francisco Chronicle*, October 20, 1955.

"Quick Sketch Comes to Life," *San Francisco Examiner*, October 22, 1955.

Lenore Hunter, "Artist's Talent Lies in Personal Qualities," *Los Angeles Times*, December 18, 1955.

Anne T. Smith, "Housewife and Mother Finds Time for Art," *Los Angeles Herald-Express*, February 21, 1957.

Frances Moffat, "Round the World Portrait Stint," *San Francisco Examiner*, May 2, 1957.

"L.A. Woman Painter Carries Art to Paris," *Los Angeles Herald-Express*, May 2, 1957.

Jules Langsner, "Art - In the Galleries," *Los Angeles Times*, December 29, 1957.

Anne T. Smith, "Marion Hewlett Pike to Paint in South America," *Los Angeles Herald-Express*, Aug. 20, 1958.

Frances Moffat, "A Localite's Salon in a Paris Studio," *San Francisco Chronicle*, January 29, 1964.

Ann Sonne, "Zubin Mehta Portrait Unveiled at Pavilion," *Los Angeles Times*, November 5, 1965.

"One of the Major New Additions...," *Pavilion*, vol. 2, p. 6, November-December 1965.

Bernhard Auer, "A Letter from the Publisher," *Time*, October 7, 1966.

"Larchmont Lady Artist Makes TIME Cover," *Los Angeles Times*, November 1966.

"Women of Distinction," *Supplement to the Los Angeles Times*, September 1967.

Hebe Dorsey, "Chanel Unpins Her Mini-Enemies," *Los Angeles Times* (?), 1967.

Maggie Savoy, "Angeleno Paints Her Way Into the Coco Chanel Legend," *Los Angeles Times*, Dec. 2, 1967.

151

Bea Miller, "I Believe in Style,"
Los Angeles Times, June 8, 1969.

Christy Fox, "Marion Pike Back in Town,"
Los Angeles Times, February 12, 1971.

Christy Fox, "Italian Party in Honor of Marion Pike," *Los Angeles Times*, May 19, 1972.

John Dektar, "An Artist's Studio,"
Los Angeles Times, September 24, 1972.

"Something Different in PB Art,"
Palm Beach Daily News, January 28, 1974.

"Marion Pike Brings Portrait Heads to PB,"
Palm Beach Daily News, February 10, 1974.

Georgia Dupuis, "Art is Faces, Clouds, Speed,"
Palm Beach Post-Times, February 17, 1974.

Phil Robertson, "Late Show at Gallery,"
Palm Beach Daily News, February 19, 1974.

"A Contemporary Setting for the Classic Sleuth?"
Sunday News, Palm Beach, February 24, 1974.

"Big Show in Palm Beach,"
Miami Herald, February 24, 1974.

"Artist Marion Pike Wows Them in PB,"
Palm Beach Daily News, February 24, 1974.

"Pike's Portraits are Larger than Life,"
Palm Beach Daily News, February 1977.

Helen Bernstein, "Pike's Peak,"
Palm Beach Daily News, February 1977.

Kevin McCarthy, "Pike's Peak,"
Women's Wear Daily, March 7, 1984.

Linda Bucklin, "The Person Behind the Face,"
Nob Hill Gazette, May 1985.

O'Dette Havel, "Portrait of an Artist,"
El Paso Times, November 22, 1986.

"Art offers great sense of history,"
Scottsdale Progress, October 12, 1989.

Laura Greenberg, "French Toast,"
Phoenix Magazine, October 1989.

"Dinner with the Artist,"
Mansion News, October 1989.

"An Artistic Celebration of French Culture,"
Phoenix Home and Garden, October 1989.

Ramona Richards, "Pike's Peak is Life, Art,"
Scottsdale Progress, October 26, 1989.

TELEVISION INTERVIEWS

Merv Griffin Show,
Los Angeles, May 3, 1985

Michael Dixon, *Phoenix Now*,
Fox-KNXP, October 29, 1989

Linda Farrell, *ABC News*,
Denver, November 28, 1989

Anthony DeGesu, Interview
La Jolla, February 1 & 8, 1990

EXHIBITIONS

THEMATIC CHRONOLOGY

This alphabetical list of subjects provides dates of events and/ or paintings, as acknowledged by the artist, with indication of the month whenever possible, the location where painted, and various additional information (Large Head, origin of the commission, etc.)
Subjects in bold letters correspond to Selected Themes.

AMSTERDAM
 1956 (June)
 1960
 1969 (with Norton and Lucille Simon)
 1974 (October)
ANGKOR-VAT
 1967 (Summer)
ARGENTINA
 1958 (Portrait of Juan Raynal)
ARIZONA
 1969 (Small landscapes, Hope collection)
ASPEN (Colorado)
 1975 (Summer) Portraits of the McBride children
 1981, 1989 (Laurie's *llama*)
AUVERGNE
 1976 (July)

BARBADOS
 1969 (May), 1970 (March), 1971 (January, 56 paintings)
 1973 (April, 20 seas & skies)
 1974 (June), 1975 (August), 1976 (August), 1977
 1978 (March), 1980 (November), 1982
 1984 (March), 1985 (March, 16 paintings), 1986 (June)
 1987 (April), 1989 (August)
BARGES ON THE SEINE (Paris)
 1984, 1985, 1986, 1987, 1988, 1989
BOUQUINISTES (Paris)
 1984, 1985, 1986, 1988
CANADA
 1980 (December) - Vancouver, views of Southridge
 1981 Montréal, portrait of André Desmarais
 1982 Montréal, portrait of Paul Desmarais
 1984 Landscapes, Portrait of France Desmarais
CANALS
 1970 (September) – to Rennes, Brittany
 1981 (July)
CAPRI 1969 (June, 9 paintings), 1970 (June), 1972 (June)
CARACAS (trips to)
 1974 (June), 1978
CHINA (trips to)
 1932, 1978
CHRIST (paintings of Heads of)
 1981
CORSICA
 1962 (with André de Vilmorin)
 1976 (at Casta)
CRECY-COUVE
 1974 (July-August - and October)
 1980 (July)
DEER SPRINGS RANCH (Santa Monica Moutains)
 1950-55
EGYPT
 1966-67 (December-January)

FLORALS

Azaleas	1951, 1954, 1956, 1962, 1973, 1982
Camelias	1969, 1975 (with *garance* background), 1975, 1980, 1982
	1983 (Large camelia on orange)
Clematis	1975 (on white background)
Delphiniums	1975
Florals (miscellaneous)	
	1970 (Water floral)
	1973 (January) Los Angeles, 13 paintings
	1975 (Blue floral on white)
	1979 (Florals on black background)
Florals in Giverny	
	1980, 1985
Gloxinias	1956, 1970-72, 1977
	1981 (July), 1983 (Large purple gloxinia)
Irises	1979 (May and November), 1981, 1982, 1984, 1986, 1989
Large compositions	
	1964, 1965, 1975 (June-July) 1980, 1982
Lilies	1974 (Red lily & purple iris, White Lilies in basket), 1980, 1981 (July), 1983 (Large red lilies), 1986 (Lilies on blue), 1988 (June), 1989
Poppies	1963 (September), 1972 (December, 2 large, +11 small watercolors), 1973 (May), 1974, 1975 (Giant poppies), 1982
Ranuncules	1974, 1979, 1980 (large)
Roses	1955, 1956, 1957, 1969 (blue background), 1975 (black background), 1975 (Large,red back ground), 1978 (Sologne)
Sunflowers	1978 (August, Sologne)
White backgrounds	
	1962, 1973

FLORENCE
 1955, 1956, 1961, 1962 (September)
 1963 (September at Villa Betania, 9 paintings)
 1964-66 (June)
 1969, 1970 (June), 1971 (November), 1972 (June)
 1978 (October), 1982 (April, 6 small paintings)
 1985 (June), 1987 (June)

GIVERNY
1980 (Summer, 6 paintings), 1985
GREECE / TURKEY
 1956 (July), 1963 (May)

APPLEBAUM Jackie
 1952 (Jackie Goosen), 1977 (Large head)
APPLEBAUM Libby
 1977
ARCHIBALD Jean
 1947 Pastel

BARCLAY Leslie Boocock
 Santa Fe
BAUDOT Jeanne
 1956 Paris
BEHRENDT George
 1954
BEHRENDT Olive
 1954 Los Angeles, Large Head
BERNADOTTE Princesse Marianne
 1984 (August) – finished in 1985
BETTIS Valerie
 1952
 1955 Drawing
 1972 Los Angeles, Large Head
BJÖRLING Ussi
 1953
BJURMAN Sue
 1958
BOISSEUIL Marc de
 1971 Large Head
BOOCOCK Doogie (Mrs. Kenyon Boocock)
 1942, 1947, 1948
 1960 New York, Large Head
 1966 Large Head – with fur hat
BORD André de
 Paris, Large Head
BRIGGS Belle Hardin Elston
 1934, 1947 (Pastel)
BRIGHT David
 1958 Los Angeles, Large Head
BRODY Sidney
 1965
 1973 Los Angeles, Large Head (unfinished)
BRODY Susan
 1973 (September), with yellow background
 1973 Large Head
BROWN Richard (Ric) Fargo
 Sketch
BROWN
 1965 Louisville, 2 portraits
BUCKLIN Linda Hale
 San Francisco
BULLOCK
 1963 (September) Large Head

CAIL Nadine
 1970-71 July, white background
 1979-80 Paris, Large head
CAMERON Helen (née De Young)
 1970 San Francisco (with sister Phyllis Tucker)
CARPENTER Janice Vest
 1975
CHALUMEAU Pascaline
 1989 Paris, Large Head
CHANDLER Otis
 1966
CHANEL Gabrielle (Coco)
 1967 (March-July) Paris, Large Head, Chanel in Studio
 1968 (April-May) Paris, Switzerland, 2 Large Heads + 2
 1969 Paris

CHENAULT Suzanne
 1983 Los Angeles, Large Head
CHURCH Betsy
 1953
CLARA Phyllis de
 1963
CLARK Kenneth
 1977 (Unfinished)
CLEVA Fausto
COBERLY Betty
 1953
COBOS Antonia
 1947 (Property of Morgan Adams Jr.)
 1966 (see Phyllis de Cuevas)
COLBERT Claudette
 1970
COOPER Diana
COOPER Duff
CUEVAS Phyllis de (Antonia Cobos)
 1966 Los Angeles, Large Head
CUKOR George
 1965 Los Angeles, Large Head

DANCO Suzanne
 1971 San Domenico (Italy), Large Head
DARBLAY Marie-Aimée
 1969 Paris
 1973 (March) pastels
DARBON Pierre
 1962 Paris, Large Head
DART Justin
 1965 Los Angeles, Large Head
DAVIDSON Gordon
 1973 Los Angeles, Large Head (unfinished)
DEL CARRIL Judy (Mme Senouf)
 1986 Paris, Large Head
DESMARAIS André
 1981 Montréal, Large Head
DESMARAIS France
 1984 Montréal, Large Head
DESMARAIS Olivier
 1982 (August), Montréal
DESMARAIS Paul
 1982 Montréal, Large Head
DEVIN Jean-Charles
 1966 Paris (in formal robe)
DEVIN Josette
 1958, 1959, 1960, 1961 Paris, Large Head, 1962
 1962 Paris, with son Pierre
 1963 Paris, 3 portraits – including one Large Head
 1966 Paris, Large Head , Josette seated
 1967 Paris – Profile portrait
 1971 Paris, Portrait in black gown, Large Head
 1972 Paris, Large Head
 1972 Paris, with sons Christian & Pierre
 1974 (January) Large head
 (August) Large Head
 1975 Paris, Large Head
 1979 Paris, Large Head
DEVIN, Pascal
 1974 Paris, Drawing
DEVIN Richard
 1971
DUQUETTE Anthony
 1956 San Francisco, Large Head
DUQUETTE Mrs. Anthony
 1952 2 portraits
 1954 With husband Tony.

ELLIS Clarissa
 1983 (April) Washington D.C.
ELLIS Ed
 1983 (March-April) Washington D.C.
ELLIS Jennifer
 1983 (April) Washington D.C.
ESCOBOSA Hector
 1955 San Francisco, Large Head

FINA Teresa de
 1941, 1970
FLANNER Janet
 1965 Paris
FRAWLEY, Mrs. Patrick
 1959 Seated
 1973 Los Angeles, Large Head
FULLER George
FULLER John M. Jr
 1948
FULLER Kit
 1951
FULLER Lina Lee
 1949
FULLER Walter G.
 1948

GARIN Monsieur
 1966 Paris
GENSER Leila
 1957, 1964
GERHAUSER Tracy
 1976
GIACOMETTI Alberto
 1966 Venice and Paris , Large Head
 1967 Large Head
GIBSON David
 1986 Large Head
GILOT Françoise (Mrs. Jonas Salk)
 1967
GIMMA Peppino
 1963 March (New York)
GOODMAN Claire
 1967 Paris
GORDON Dan
 1952 Los Angeles (2 paintings)
GORDON Nadia Nerina
 1972 (May) London
GUIBERSON
 1964
GULDA Fiedrich

HABER Antoinette Zellerbach
 1947 Pastel
HAILE-SELASSIE (Emperor of Ethiopia)
 1969
HALE "Happy"
 1953
HALE Prentis
HALE Prentis Jr "Rusty"
 1950
HALLE Geraldine (Mrs. Bruce Halle)
 1989 (December) Los Angeles, Large Head
HALLOWELL John
 1968
HART Al (National City Bank, Los Angeles)
 1969 (September)
HECHT Harold
HELLMAN Mickey
 1966 San Francisco

HENNOCQ Monsieur (Sommelier, Le Grand Véfour, Paris)
 1967 (May), Large Head, commissioned by Justin Dart
HEWLETT FULLER Jane
 1933, 1934 (Summer) Carmel
 1957, 1960 (2 portraits)
HILL Marion
 1952 San Francisco, Pastel
HOISKO Andrew
 1939
HOISKO Lena
 1938
HOPE Bob
 1956 Large Head (painted in Malvina Hoffman's studio)
HOPE Dolores
 1942, 1945
 1947 Pastel ("Don't polish the apple" – Frank Lloyd Wright)
 1973 (January) 3 large heads
HOPE Kelly
 1940
HOPE Linda
 1940 (with teddybear)
 1943 (with ribbons)
 1956, 1958 (in red dress)
HOPE Nora
 1948 Pastel
HOPE Tony
 1954 Los Angeles (1955 Award, L.A. County Museum)
HORNBLOWER Henry
 1964
HOURS Magdeleine
 1967 Paris, Large Head
HOWARD Eleanor Harris
 1966 New York, Large Head
HOWARD Jean
 1965 Los Angeles, Large Head
HOWE Thomas Carr
 1955 California Palace of the Legion of Honor, SF
HUDSON Sara
 1986 Paris, Houston (3 paintings)
HUNEKE Betty
 1946 Pastel
HUNEKE Lydia
 1946 Pastel
ISAACS Senta
 1953, 1960
JACKSON Dorothy
 1981 (July) Paris
JOYCE Faie
 1963 (June)
KEELER Ruby
KENDALL Dwight and Suzanne
 1983 Los Angeles, Large Heads
KERESEY Ann
KLEINER "Chiki"

LABALME George
 1953 Los Angeles, Large Head (unfinished)
LANDY Nat
LANZA Mario
 1955 (in Othello -painted at Warner Studios)
LAUDER Estée
 1974 Palm Beach, New York, Large Head
LAZARD Children
 1956-57 New York, Paris
LE BOURGEOIS Mrs.
 1979 (November) Paris
LEE-KWAN-YEW
 1981 (November) Singapore, Large Head

LEES, Walter
 1980 Paris
LeROY Mervin
 1966 Los Angeles
LE TROQUER Michèle
 1986 Paris, Large Head
LOBKOWITZ Prince Edward de
 1982 Paris, Large Head
LOBKOWITZ Princesse Françoise de
 1982 Paris, Large Head
LOPEZ Ariane
LOURAN, George
 1970 (December) Paris
LOYRETTE Anne-Marie
 1973 Paris, Large Head
LUDINGTON Wright
 1961 Santa Barbara
 1966 Large Head
LUSTGARTEN Edgar
 1954 Los Angeles
LUTHER Joan
 1968 (unfinished)

MACK Helen
 1958 (+ several unfinished, non dated paintings)
MACK Laurie (McBride)
 1968 Pasadena, Large Head
MACK Peter
 1948 Pasadena
McBRIDE Kathie, Johnny, Peter
 1975 (Summer) Snowmass (Colorado), 3 portraits
McCARTHY Mary
 1963 Paris, Large Head
McGUIRE John
 1970 (May) Los Angeles, Large Head
McHOSE Sally
 1948 Pastel
McNAUGHTON Malcolm
 1972 (August) Honolulu
MALATESTA Mildred
 1968 (unfinished)
MALRAUX André
 1976 Paris, Large Head (posthumous)
MARSHALL David
 1980 Paris, Large Head
MEHTA Zubin
 1965 Los Angeles, Large Head (Chandler Pavilion)
 1965 (in the orchestra, 10 paintings)
MILLER Robert
 1966 Paris, San Francisco
MOORE Eliza Lloyd
 1970 Sketch
MUDD Tom
 1956 (unfinished)
MURPHY Franklin
 1971 Los Angeles, at Murphy Hall in UCLA
MURRAY William
 1974 Palm Beach, Large Head
MYLNARSKI Doris
 1963 Paris

N'DOURI Amaseri
 1963 Paris
NERINA Nadia Gordon
 1972 (May) London
NEVEU Bernard
 1972 Paris, Large Head (posthumous)
NUNEZ Gil
 1945 Los Angeles, Sketch

PASCALE Kay
 1982 Pasadena
PAPADOPOULOS Iana (Florence)
PAULO
 1955 (See L.A. Times excerpt)
PERLS Frank
 1967 Paris, Large Head
PIKE Jack (John Jacob)
 1935 Pastel
PIKE Jeffie Durham
 1951 (pastel), 1953, 1954, 1958
 1970 Los Angeles, Large Head
PIKE John Jacob Jr.
 1946, 1948, 1949, 1951, 1952, 1953
 1954 (2 portraits)
PIKE Thomas P. & Mary
 1960 Pasadena, Large Heads
POPE Generoso
 1983 (posthumous)
POPE JOHN-PAUL II
 1983 Paris, Large Head
PORTER Antoinette
 1949
PORTER Peggy
 1954-55

RAULIN Valérie
 1986 Paris, Large Head
RAOUL-DUVAL, Ariane (Pike)
 1966 Paris, Drawing
 1977-Paris (in black shawl), 1983
RAOUL-DUVAL, Christian
 1960 (Summer in Ibiza)
 1967 Josette and Christian
 1970, 1972 Paris, Large Head
 1973 Paris
RAOUL-DUVAL Camille
 1979, 1988
RAOUL-DUVAL Jean
 1984 (La Roche-en-Breuil)
 1987, 1988
RAOUL-DUVAL Marie
 1984, 1985, 1986
RAOUL-DUVAL Nathalie
 1982
RAOUL-DUVAL, Pierre
 1960 (Summer in Ibiza) 2 portraits
 (December) portrait with scarf ("Le Petit Prince")
 1962, 1967 Paris, Large Head, Portrait with scarf
 1968, 1971 (September) Large Head
 1972 Paris, Large Head
 1973 (June) Paris, Large head
 1975 Paris, Large Head
REAGAN Ronald
 1966 (September) Commissioned by Time Magazine
REAGAN Nancy
 1983 White House, Washington D.C. – Large Head
REYNAL, Juan
 1958 Buenos-Aires
RICCI "Lalanne" de
 1979-80 (November), Paris
RITCHARD Cyril
ROCHESTER
 1959 Paris
ROPERS
 1960
ROSEWITHA (Ms. Frankfalle)
 1960, 1963 Paris

ROTTMAN Astrid
 1989 Los Angeles, Large Head
ROSENTHAL Mrs.
 1968
ROUART (Julie, née Manet)
 1956-57 Paris (2 portraits)
 1963 Paris (with Mrs. Paul Valéry)
ROYER Dorothy
 1954 Los Angeles
RUBINSTEIN Arthur
 1968 (July) Marbella, Spain – Large Head
 1971 Los Angeles, Large Head
RUNYON Cornelia
 1951 Seated
 1954 First Large Head (2 versions)
RUSSELL Rosalind
 1970 Los Angeles, 3 Large Heads

SALOMON Jacques
 1973 Paris
SARDA Nicole
 1982 Paris, Large Head (2 paintings)
SARDA Philippe
 1987 Paris, Large Head
SAUNDERSON Sandy
SCHLEIFF J.W – Property of Mrs. Ruth Hofstetter
SCHLUMBERGER Jean
 1972 Paris
SCHREIBER Taft (Universal Studios)
 1957 Los Angeles, Large Head
SELF-PORTRAITS – See special entry
SIMON Robert
 1958 Los Angeles
SIMON Don
SIMON Lucille
 1965 Los Angeles, Large Head
 1966 Los Angeles, Large Head
SIMON Norton
 1962 Los Angeles, Large Head
 1966 Los Angeles, Large Head (unfinished)
SIMON Pamela
 1985 Los Angeles, Large Head
SMITH Margot (Mrs. Samuel Thomas)
 1949 Los Angeles
SINATRA Mr. and Mrs. Frank
 1978 (November) Los Angeles (unfinished)
SORIANO Rafael
 1956 Los Angeles
SPANOS Faye (Mrs. A.G. Spanos)
 1983 Large Head
STEIN Mrs. Jules (Stein Eye Institute, UCLA)
 1966 Los Angeles, Large Head
STERLING Dr. Wallace
 1966 Los Angeles, Large Head

TAYLOR Maggie
TIPO Maria
 1952 2 studies
TUCKER Phyllis
 1970 (with sister Helen Cameron)
VALERY Mme Paul
 1958-59 Paris
 1963 Paris (with Mme Ernest Rouart)
VAN ALLEN Louise
VANDERLIP Elin and Narcissa
 1949 Los Angeles (2 paintings)
VEST Janice (Carpenter)
 1975 Los Angeles

VARGAS Chavela
 1947 Guatemala City
VIDOR-PARRY Sue
VILLAINE Pamela de
 1975
VILMORIN André de
 1970, 1973 Paris
VILMORIN Henri de
 1960 Paris
VILMORIN Louise de
 1961 Paris (Louise reading)
 1964 (January) Paris (Louise reading)
 1965 Paris, Large Head
 1968 Paris, Large Head
VILMORIN Sophie de
 1973 Paris
VOGÜE Patrice de
 1966 Paris
WALKER John III
 1966 Washington, D.C. (National Gallery), Large Head
WAYNE John
 1985 Los Angeles, Large Head and 2 portraits
WEAVER Laurie
 1955, 1963 Seattle
WESSON John
 1973 (May), 1983
WESSON Lee
 1966
WESSON Marion
 1973, 1978, 1989
WILLIM John
 1974 Palm Beach, Large Head
WOPPLE Georgia
WRIGHT Frank Lloyd
 1948 Drawing
WRIGHT Iovanna
 1948 Pastel

YOUNG Samuel
 1986 Los Angeles
YUGOSLAVIA, Prince Alexander of
 1972 Paris, Large Head
YUGOSLAVIA, Princesse Barbara of
 1975 (June-July) Paris, Large Head
YUGOSLAVIA, Prince Dushan de
 1980 (July) Paris, Large Head

ZABERT Gilberto
 1972 Torino, Large Head
ZORTHIAN Jerry
 1955 Sketch

(end of PORTRAITS)

RE Isle of (France)
 1973 (November) 6 landscapes
ROOFTOPS (Paris)
 1962, 1963, 1964, 1965, 1966, 1967
 1969 (November) 6 paintings
 1970 (July) 7 paintings
 1971 (June) 6 paintings – see Zabert catalog
 1972, 1973, 1980 (blue sky), 1982
ROOFTOPS IN SNOW (Paris)
 1965, 1966, 1975, 1987
RUE DE NEVERS (Paris)
 1979 (August) 2 paintings, 1980
 1981 (October) 3 views
RUSSIA (trip to)
 1971-72 Winter

SAINT-AVIS (France)
 1975 Landscape
SAINTE-CHAPELLE (Paris)
 1973 (February), 1978, 1980, 1981
SAMARITAINE (Paris)
 1980, 1981, 1982
SAN FRANCISCO
 1956-57
 1963, 1965
 1981 (July)
SANTA FE (trip to)
 1981
SEINE and LA CITE (Paris)
 1977, 1980, 1986
SEINE & PAVILLON DE FLORE (Paris)
 1970 Sunset
 1971 4 paintings with barges
 1989 Sunset

SELF-PORTRAITS (51 identified to date)
 1940 Los Angeles, Pastel
 1942 Los Angeles
 1945, 1946
 1953 (In overcoat, in robe, in yellow sweater)
 1954 Several paintings
 1956
 1957-58 2 self-portraits (one exhibited in Los Angeles)
 1960 Paris, Large head
 1961 Paris – 1962 (on white background)
 1962-65 Paris, Large Head
 1963 (April) Large head
 1965 (January) 2 self-portraits
 1968 (on red background)
 1970 Los Angeles, Large Head, and studies
 1973, 1974 (Self-portrait in blue)
 1975, 1978, 1982 2 self-portraits
 1983, 1986
 1988 Guatemala (with hat)
 1989 Paris (unfinished)

SIAM (trip to)
 1967
SINGAPORE (trip to)
 1981 (November) Portrait of Lee-Kwan-Yew

SOLOGNE (La Pacaudière)
 1967 First stay
 1968 (May) 10 landscapes
 (August) 10 landscapes
 1970 (Summer)
 1971 (Summer)
 1973 (February) 11 landcapes
 (July) 2 large ldscp, 3 small, 2 skies
 (October) 11 paintings.
 1974 (July and August)
 1975 (May) 2 landscapes
 (July) 2 landscapes
 1978 (August) large sunflowers, sky, view of road
 1979 (September)
 1980 (April)

SPAIN (trips to)
 1954 (July) Madrid
 1962
 1964 (with Norton and Lucille Simon)
 1970 Madrid

SWITZERLAND (trips to)
 1958 Christmas in Gstaad
 1967, 1968 trips with Chanel
 1982 (February) Gstaad

TAHITI (trip to)
 1964 (Summer)

VAUCLUSE
 1962 (April-May)
 1966 (April-May) 4 paintings
VENICE
 1924 first trip with parents
 1954 (August)
 1962 (June – Biennale)
 1963 (Summer)
 1964 (June – Biennale)
 1965
 1966 (June – Biennale)
 1972 (May)
 1975 (January) Paris – "paintings from old sketches"
 1978 (October)
VERRIERES-LE-BUISSON
 1962 "Le Salon Bleu"

Note from the author.

This Thematic Chronology should not be confused with a catalog. We hope it will help all those interested in the artist's work to date early paintings and to observe the re-currence of several subjects. It does not pretend to be comprehensive.

Sources :
 Marion Pike
 General catalog of Marion Pike's works (currently in process)
 Artist's correspondence (1961-1982)
 Collectors

COLLECTORS

Mr. Morgan Adams Jr., Los Angeles
Mrs. Brian Aherne, Boca Grande, Florida
Ahmanson Foundation, Los Angeles
Mr. and Mrs. d'Almeida, Paris
Mr. and Mrs. Thierry André, Paris
Mr. Jeffrey Angell, Los Angeles
Mr. and Mrs. Luis Ansa, Paris
Mme. Jacqueline Aoun, Paris
Mrs. Jackie Applebaum, Los Angeles
Mrs. Henry Bagley, Paris
Mr. and Mrs. Rutgers Barclay, Santa Fe
Mr. and Mrs. William Beadleston, New York
Mr. Adron Beene, Palo Alto
Ms. Barbara Beretich, Claremont
Princess Marianne Bernadotte, Stockholm
Mrs. Kenyon Boocock, New York
Mr. and Mrs. André de Bord, San Francisco
Ms. Senta Bosi, Florence
Mr. and Mrs. John Brinsley, Los Angeles
Mrs. Sidney Brody, Los Angeles
Mr. and Mrs. Lee L. Brown, Louisville
Mrs. Richard F. Brown, Fort Worth
Mr. and Mrs. William Bucklin, San Francisco
Mrs. Bullock, St. Louis
Mr. and Mrs. Dennis Bunyan, Scottsdale
Mr. and Mrs. Arch Butts, Los Angeles
Mr. Sylvain Cabanau, Chatou
California Palace of the Legion of Honor
Mr. and Mrs. Edward Carter, Los Angeles
Mr. and Mrs. Jean-Luc Chalumeau, Paris
Mr. and Mrs. Otis Chandler, Los Angeles
Mr. and Mrs. Harrison Chandler, Pasadena
Mr. and Mrs. Robert Cheesewright, Pasadena
Mr. and Mrs. Gene Chenault, Los Angeles
Claremont Colleges
Mr. and Mrs. William Coberly, Los Angeles
Ms. Claudette Colbert, New York

Mrs. Mary Coquillard, Los Angeles
Mrs. Anne Craemer, Malibu
Mrs. Suzanne Danco, Florence
Mrs. Justin Dart, Pebble Beach
Mrs. MaryLou Daves, Los Angeles
Mrs. Cookie Day, Los Angeles
Mr. and Mrs. André Desmarais, Montréal
Mr. and Mrs. Paul Desmarais, Montréal
Mme. Jean-Charles Devin, Paris
Mr. and Mrs. Anthony Duquette, San Francisco
Mr. and Mrs. Roy Durham, Los Angeles
Dr. Ari Edwards, Paris
Mr. and Mrs. William Egolf, Santa Fe
Mr. and Mrs. Edward C. Ellis, Santa Monica
Mr. Charlie Fairbanks, Santa Barbara
Mr. and Mrs. Patrick Frawley, Los Angeles
Mr. and Mrs. Fuller, Los Angeles
Mr. Jefferson Fuller, Mexico City
Ms. Kit Fuller, Los Angeles
Princess Tassilo de Furstemberg, Paris
Mr. and Mrs. Charles Gillespie, San Francisco
Mr. and Mrs. Joseph Gimma, New York
Mr. and Mrs. Charles Gordon, London
Mr. Z. Wayne Griffin, Los Angeles
Mrs. Antoinette Haber, Malibu
Mr. Prentis Hale Jr., San Francisco
Mr. Bruce Halle, Scottsdale
Mr. Richard Hare, New York
Mrs. Enid Haupt, New York
Mr. Harold Hecht, Los Angeles
Ms. Marion Hill, Los Angeles
Mrs. Ruth Hoffstetter, Sun City
Mr. and Mrs. Bob Hope, Los Angeles
Mr. and Mrs. Tony Hope, Los Angeles
Mr. and Mrs. Jack Howard, New York
Mr. John Huneke, Menlo Park
Mr. Jones de Joria, Los Angeles

Mr. and Mrs. Frank Kelcz, New York
Mr. and Mrs. Dwight Kendall, Los Angeles
Ms. Ann Keresey, New York
Mr. and Mrs. Richard Kleiner, Beverly Hills
Mr. and Mrs. George Labalme, New York
Mr. Parker Ladd, New York
Mr. and Mrs. Roger Lapham, Pebble Beach
Estée Lauder, Inc., New York
Mr. Walter Lees, Paris
Mme. Le Bourgeois, Paris
Estate of Mr. Mervyn LeRoy, Los Angeles
Dr. Michelle Le Troquer, Paris
Mrs. Peter Lewis, San Francisco
Mr. and Mrs. Rudolph Liebig, Los Angeles
Prince and Princess Edward de Lobkowicz, Paris
Mr. and Mrs. Jean Loyrette, Paris
Mr. Wright Ludington, Santa Barbara
Mr. and Mrs. John E. Mack, Pasadena
Mr. John Erik Mack, Pasadena
Mr. and Mrs. Allen Manning, Palm Beach
Mrs. Lena Marley, Durham
Mr. and Mrs. Oscar Martinez, Caracas
Mr. and Mrs. John McBride, Aspen
Mr. William McCarthy, Paris
Mr. Frank McCarthy, Los Angeles
Mr. and Mrs. David McMahon, Fort Worth
Mr. Malcolm McNaughton, Honolulu
Ms. Tina McPherson, New York
Mr. and Mrs. Eduardo Mendoza, Caracas
Mr. and Mrs. Robert W. Miller, San Francisco
Mrs. Virginia Milner, Los Angeles
Mme Henri Mouren, Paris
Prime Minister and Mrs. Brian Mulroney, Ottawa
Murphy Hall, UCLA, Los Angeles
Ms. Doris Mylinarsky, Paris
Mr. and Mrs. N'Douri, Paris
Mme Neveu, Paris
Ms. Martha Parrish, New York
Mr. and Mrs. David Parry, Los Angeles
Mrs. Ariane Pike, Los Angeles
Mr. John J. Pike Jr., Los Angeles
Mr. and Mrs. Thomas P. Pike, Pasadena
Mr. Tyrone Pike, New York
Mr. Christian Raoul-Duval, Paris
Mr. and Mrs. Pierre Raoul-Duval, Paris
Mr. and Mrs. Christopher Rathbone, Scotland
Mr. and Mrs. Alexander Reisser, Germany
Mr. Juan Reynal, Buenos Aires
Countess de Ricci, Paris
Rottman Foundation, Los Angeles
Mrs. Dorothy Royer, Los Angeles
Mrs. Arthur Rubinstein, Paris
Mr. Jacques Salomon, Paris
Santa Barbara Museum

Mr. and Mrs. Michel F. Sarda, Phoenix
Mme Nicole Sarda, Paris
Mr. Jean Schlumberger, New York
Mme Senouf, Paris
Mrs. Susan Shultz, Paradise Valley
Mrs. Lucille E. Simon, Los Angeles
Mr. Norton Simon, Beverly Hills
Mr. and Mrs. Donald Simon, Beverly Hills
Mr. U. Thiam Sing, Singapore
Singapore National Museum, Singapore
Dr. Irvin Sittler, Los Angeles
Smithsonian Institute, Washington D.C.
Mr. and Mrs. Alex Spanos, Stockton
Stein Eye Institute, UCLA, Los Angeles
Mrs. Louise Steinberg, Los Angeles
Mrs. Marilyn Stuart, Los Angeles
Mr. and Mrs. Reese H. Taylor, Pasadena
Mr. and Mrs. Samuel Thomas, Los Angeles
Mr. and Mrs. Maurice Tobin, Washington D.C.
Princess Melekper Toussoun, Paris
University of Southern California
Ms. Janice Vest, Los Angeles
Mr. and Mrs. Aubert de Villaine, Paris
Mme André de Vilmorin, Paris
Mme Sophie de Vilmorin, Paris
Mr. Patrice de Vogüe, Paris
Mr. and Mrs. Greg Wallace, Houston
Mr. Michael Wayne, Los Angeles
Mrs. Virginia Weaver, Seattle
Mr. Lee Wesson, Blytheville
Mr. and Mrs. Brayton Wilbur, Burlingame
Mr. and Mrs. John Willim, Palm Beach
Prince and Princess Alexander of Yugoslavia, Paris
Mr. Gilberto Zabert, Torino

We apologize to the collectors who may have been omitted from this list.

INDEX

This index does not include collectors and photographers. For information, please consult Collectors List and Photo Credits.

PHOTO CREDITS

Note. Each photograph is identified by a double group of digits.
The first group identifies the page.
The second group relates to the photograph number on the page.

David Bailey, courtesy of Vogue Magazine, 36-62
J.C. Boniface, 110-95
Sylvain Cabanau, 44-87, 46-97
Caroline Photography, 102-83
Bob Davidoff, 41-78, 41-79
Estée Lauder, Inc., 91-67
Jane Gillespie, 24-29, 27-37, 29-43, 29-44, 29-45, 30-47, 30-48, 30-49
Prentis C. Hale III, 23-25
Frank Kelcz, 140-97
Sam Little, 125-11, 125-13
John Erick Mack, 148-140
Laurie McBride, 147-133
Brian Merrett, 46-95, 66-27, 67-29, 72-36, 100-78, 101-80, 123-4, 135-70
Mila Mulroney, 76-41+42
Marion H. Pike, 32-53, 33-54, 39-71, 40-76, 43-85, 45-92, 55-11, 58-14, 59-17, 63-22, 67-28,
 74-39, 77-43, 77-44, 84-54, 86-57, 86-58, 87-59, 89-63, 146-131+132, 147-135 to 138,
 148-139
Pierre Raoul-Duval, 140-94, 144-117
Michel F. Sarda, 17-7, 18-all, 19-12, 20-all, 21-18+19, 23-22 to 24, 24-28+31, 25-33, 28-41+42, 34-56+58,
 36-63, 38-69 to 70, 39-72, 40-73 to 75, 42-all, 43-84, 44-86+88 to 90, 46-94+96+98,
 47-100, 49-all, 50-all, 52-all, 53-9, 54-10, 58-15, 59-16, 60-all, 64-23, 68-30, 75-40, 79-47,
 80-48, 81-all, 85-56, 87-60, 89-62, 91-66, 94-71, 96-all, 97-75, 100-79, 103-84, 105-86,
 106-all, 107-89, 108-all, 109-92, 110-93+94, 111-all, 112-98, 123-1, 124-all,
 125-9+10+12+15, 126-16+17, 127-22+24+26 to 28, 128-30, 129-34+36+38, 130-42+45,
 131-47 to 50, 132-52+54, 133-58, 136-71+73, 137-78 to 81, 138-all, 139-all, 140-96+98,
 141-99, 142-107 to 109, 143-110 to 114, 144-116+118+120, 145-121 to 125, 146-128+130,
 148-141 to 143
Philippe F. Sarda, 136-76
Pierre J. Sarda, 51-5
Singapore National Museum, 98-76
Lionel Stein, 125-14
Studio Michel, 88-61
U.S. Presidential Archives, Washington, D.C., 102-81
Janice Vest, 147-134
Lee Wesson, 140-95
Frank Lloyd Wright Archives, 21-17
Daniel Young, 35-60
Zeni Photography, 41-77